# Appalachian Bounty
## Nature's Gifts from the Mountains

A Collection of Essays
and Photographs

Michael Joslin

The Overmountain Press
JOHNSON CITY, TENNESSEE

ISBN: 1-57072-164-5
Copyright © 2000 Michael Joslin
All Rights Reserved
Printed in the United States of America

1 2 3 4 5 6 7 8 9 0

*To Pam*

# CONTENTS

Introduction . . . . . . . . . . . . . . . . . . . . . . . . . . . . . . . vii
Creasy Greens . . . . . . . . . . . . . . . . . . . . . . . . . . . . . . 1
Ramps . . . . . . . . . . . . . . . . . . . . . . . . . . . . . . . . . . . . 4
Wood Frogs. . . . . . . . . . . . . . . . . . . . . . . . . . . . . . . . 7
Morels . . . . . . . . . . . . . . . . . . . . . . . . . . . . . . . . . . 11
Shortia . . . . . . . . . . . . . . . . . . . . . . . . . . . . . . . . . . 14
Dogwood Blight . . . . . . . . . . . . . . . . . . . . . . . . . . . 19
Big Butt Trail . . . . . . . . . . . . . . . . . . . . . . . . . . . . . 24
Gardens of the Blue Ridge . . . . . . . . . . . . . . . . . . 29
Wild Strawberries . . . . . . . . . . . . . . . . . . . . . . . . . 34
Early Apples . . . . . . . . . . . . . . . . . . . . . . . . . . . . . 39
Royal Paulownia . . . . . . . . . . . . . . . . . . . . . . . . . 43
Hemlock Hill . . . . . . . . . . . . . . . . . . . . . . . . . . . . 47
Hiking Mount Mitchell in Summer . . . . . . . . . . . . 52
Chestoa View Overlook . . . . . . . . . . . . . . . . . . . . 56
Abandoned Mines . . . . . . . . . . . . . . . . . . . . . . . . 60
Waterfalls . . . . . . . . . . . . . . . . . . . . . . . . . . . . . . 65
Uppercreek Falls . . . . . . . . . . . . . . . . . . . . . . . . 69
Asheville Botanical Gardens . . . . . . . . . . . . . . . . 73
Heritage Roses . . . . . . . . . . . . . . . . . . . . . . . . . . 78
Blueberries . . . . . . . . . . . . . . . . . . . . . . . . . . . . . 83
Gray's Lily . . . . . . . . . . . . . . . . . . . . . . . . . . . . . 87
Wildlife Encounters . . . . . . . . . . . . . . . . . . . . . . 91
Craggy Gardens . . . . . . . . . . . . . . . . . . . . . . . . . 95
The Black Brothers . . . . . . . . . . . . . . . . . . . . . . . 99
Chimney Rock . . . . . . . . . . . . . . . . . . . . . . . . . 104
Sassafras . . . . . . . . . . . . . . . . . . . . . . . . . . . . . 108
Flowers of the Summer Pasture . . . . . . . . . . . . 112
Dahlias . . . . . . . . . . . . . . . . . . . . . . . . . . . . . . 116
Ginseng . . . . . . . . . . . . . . . . . . . . . . . . . . . . . . 119
Autumn Flowers . . . . . . . . . . . . . . . . . . . . . . . 123
Ivory Gail: Herbalist . . . . . . . . . . . . . . . . . . . . . 127
Heritage Apples . . . . . . . . . . . . . . . . . . . . . . . . 132

Flat Rock Trail . . . . . . . . . . . . . . . . . . . . . . . . . . . . . . 135
Hawthorns, Dogwoods, and Witch Hazel. . . . . . . . . . . . 139
Pinnacle of the Blue Ridge . . . . . . . . . . . . . . . . . . . . . 143
Bright's Trace. . . . . . . . . . . . . . . . . . . . . . . . . . . . . . . 147
Big Lynn Tree. . . . . . . . . . . . . . . . . . . . . . . . . . . . . . . 153
Holly. . . . . . . . . . . . . . . . . . . . . . . . . . . . . . . . . . . . . 155
Lichens and Mosses . . . . . . . . . . . . . . . . . . . . . . . . . 158
Mount Mitchell's Winter Attractions . . . . . . . . . . . . . . 162
Roan Highland Balds . . . . . . . . . . . . . . . . . . . . . . . . . 167
Gingercake Mountain . . . . . . . . . . . . . . . . . . . . . . . . . 174
Hawksbill. . . . . . . . . . . . . . . . . . . . . . . . . . . . . . . . . . 178
Table Rock . . . . . . . . . . . . . . . . . . . . . . . . . . . . . . . . 182
Veins of Ore: Cranberry Mines Echo the Past . . . . . . . . 186
Winter Pasture . . . . . . . . . . . . . . . . . . . . . . . . . . . . . 190
Winter Ways . . . . . . . . . . . . . . . . . . . . . . . . . . . . . . . 194
Ladybugs . . . . . . . . . . . . . . . . . . . . . . . . . . . . . . . . . 198
Hot Springs . . . . . . . . . . . . . . . . . . . . . . . . . . . . . . . 201
Painters . . . . . . . . . . . . . . . . . . . . . . . . . . . . . . . . . . 206
Toe River . . . . . . . . . . . . . . . . . . . . . . . . . . . . . . . . . 211
Maple Sugar. . . . . . . . . . . . . . . . . . . . . . . . . . . . . . . 219
Pussy Willow . . . . . . . . . . . . . . . . . . . . . . . . . . . . . . 223

# INTRODUCTION

For thousands of years people have come to the mountains we call the Southern Appalachians to share in the bounty Nature has showered so profusely on this region. Great numbers and varieties of trees, bushes, flowers and weeds, minerals, mammals, reptiles, amphibians, and birds find homes here. Fresh, clean water flows abundantly. Millions of years of weathering have worn down mountains higher than the Himalayas, endowing the valleys with deep rich soil. Early settlers marveled at such richness and eagerly sought to find their place in this Eden.

Beauty came with the natural riches, an important part of God's gift. It is a four-fold beauty, with each season bringing its own particular magic to forest, field, and mountain. This sure cycle also teaches us not to fear the process of our own lives, showing us that each age has its purpose, and that life's ending is only a new beginning.

The essays and photographs that make up this book come from the last decade of the twentieth century. Most appeared in periodicals and take their place from the seasonal round. Each piece can be read for itself, but all combine to give a composite picture of life here today. The past plays an important role in many of the stories, but it is looked at from the perspective of the present.

The message of the book is simple, and I hope, clear. What is here is worthy of our regard and our love. It is a valuable gift, but also a fragile one. We should nurture what God has given us, not recklessly spend our inheritance. These stories and pictures are not substitutes for the wonders they present; they are simply introductions. When you hike along a high mountain trail, or pick your own blueberries, or soak under a waterfall, or pause to admire the stark beauty of a winter landscape, remember that each is in your protection.

Michael Joslin — December 2000

## CREASY GREENS

In late winter, although snow still lies in sheltered coves and temperatures sink below freezing at night, the first of spring's free-handed bounty has pushed up through the frozen soil. Creasy greens are ready for gathering, cooking, and eating.

Part of the fun is gathering the creasies. I take my children out to the pasture and garden spot to get them as soon as the snow melts in late February or early March. The bright green plants are easy to spot and to harvest.

These tasty vegetables have a split personality. Under the name of cress, the leaves were used in thin sandwiches during the tea parties of Victorian England, but known as creasy greens in the mountains, they have served as an unsurpassed spring tonic for generations of rural folks. Even today they link the past to the present with a living thread.

Ninety-year-old Pauline Street knows them well.

"Lord, it's the best stuff. I used to pick it by the sackful just this time of year," she says, her light blue eyes shining as she sits in the wheelchair where she spends most of her days.

*Creasy greens appear while snow still lies on the ground.*

Unable to get out much now, Pauline is happy to receive a mess of creasy greens that we have gathered for her this cool Sunday. In the past, as soon as the snow receded in the spring, she and other folks combed the fields, stream and road sides, and waste spaces, looking for these wild greens that meant the first fresh vegetables after a winter of salt pork and game.

"You get it when it comes up, sometimes early, sometimes later. I used to pick it in Paul Garland's fields," says Pauline, turning the bright green creasies over in her hands.

*Dylan Joslin cuts creasy greens.*

A member of a younger generation, Linda King, remembers creasy greens as a part of her childhood heritage. Her mother and grandmother taught her from infancy how to gather the plant and prepare it for the table. Raised on Cane Creek outside of Burnsville, Linda says she has gathered the greens "for as far back as I can remember."

"I usually gather my own. I find them at my mom's in Burnsville, or at the farm at Whittington Bottom on Cane River. Since Dad sowed seed, they're really about everywhere: along the edge of the pasture, since we don't have animals any more, and in the previous summer's garden before we plow for this year," she says.

Many mountain folks used to do as her father and sow cress seeds to insure a large crop in the following spring. Some buy packets of the seeds; others simply follow nature's

plan, as Linda's father, Lawrence King, did.

"My father would let some of the plants go to seed, then collect them and grow it. Generally, we'd sow it in late summer or early fall. He did that for as many summers as I can recall, until his death last fall," she says.

Gathering the plant is as simple as sowing. You take a knife and cut the head from the root. When you have a poke full, you're ready to clean the greens and prepare them for cooking.

Pauline's recipe is simple. You cut the core out of the plant, then rinse the leaves well. Boil them until tender, then fry in grease. They are also easy to save. After electricity came up Greasy Creek, Pauline would take her creasy greens, boil them by the sackful, then save them in the freezer. "You just take them out and fry them in grease, and they're just as good," she says.

While Linda was taught to cook her creasies in the old way, she has developed a more healthful technique of preparing them.

"My mom and grandmother fixed them the traditional way—boil them and cook them with country ham or fat back or salty bacon for the grease. I'm a vegetarian. I steam them, then cook them for a couple of minutes in olive oil."

"But you still have to have cornbread to go with them," she says, then laughs.

In addition to making tasty cooked greens, creasies can be added to salads raw to add a bit of the wild to the tame lettuce and other ingredients. While this is not the preferred use of the plant in the mountains, it provides a vitamin-rich addition in a season when there is little to find in the garden. And the price is right—time spent outdoors in the sun of late winter is the only cost.

# RAMPS

Mother Nature can be mighty tasking during the hard winter months in the mountains. But when spring comes, she rewards and nurtures with a hand as bountiful as it was hard. Ramps, the wild mountain leek, are one of the rewards that mountain folks receive when the snows recede.

The Indians introduced the earliest white settlers to this healthful herb. Ever since then, families have looked for the green shoots to push through the brown cover of decaying leaves or even through a blanket of late snow to provide them relief from a winter's diet of dried and canned vegetables.

Ramp aficionados extol both the flavor and the health-providing benefits of the wild leek. They eat it raw, fried, baked, boiled, and roasted over an open fire. It appears in stews, scrambled eggs, fried potatoes, spaghetti sauces, and soups. Even the foreign delicacy, *vichyssoise*, a creamy potato and leek soup, is excellent when made from ramps.

Ramp feasts range from the lone mountaineer who takes a loaf of bread and a tub of butter into the hills to eat with the raw ramps beside a cold stream, to community-wide festivals that draw participants from hundreds of miles away.

My family likes to hike into the mountains to a favorite patch and dig a mess to bring home for cooking. The pleasure of roaming through the spring woods with wild flowers nodding under the warming sun is its own reward, and

*Mitchell Joslin digs ramps when they first appear in late winter.*

— 4 —

the task of digging the ramps from a spreading bed is also fun.

But the real treat comes with the eating. While we may nibble on the bulbs and leaves coming down the hill, we cook most of the ramps. Diced and sauteed ramps taste good cooked with scrambled eggs and fried potatoes.

Simply covered in foil and roasted in the oven, they go well with almost any meat as a side dish, and they combine nicely with ground meat in sauces and soups.

*Christine Lassiter and Bill Leavell gather a mess of ramps on a warm spring day in 1996.*

One of the best ways to initiate friends to the world of ramps is to take them along for the gathering as well as the eating. Many today have never foraged in the woods for food. The experience is usually a pleasant surprise, especially at a season like this one when everything green in the supermarket is depressingly expensive.

Judge Bill Leavell and writer Christine Lassiter accompanied us on one early spring expedition. After puffing up the steep mountainside, they plunged enthusiastically into the dark, rich soil as they carefully dug the ramps with sharpened sticks to avoid spoiling the tasty bulbs. Each carried a handful down to the house.

Some families like to gather and eat their ramps in the same spot. Ted Ledford, born and raised on White Oak Creek in Mitchell County, North Carolina, joins his brothers Lee Roy and Darrell each spring to take their families into the woods for their ramp feast.

"We usually go back in on Gouges Creek. We'll take potatoes and fatback and ham. And if we can find some morels (wild mushrooms), we'll take them along too.

"We like to find a stream where we can wash them. If we can manage to find a stream with trout, we can catch some trout to eat with them," says Ted Ledford, licking his lips at the memories.

He remembers taking a Mitchell High School exchange student from Madrid, Spain, with the family one spring. He collected and ate the wild leeks like a native.

"We teased him that he was probably the only person from Madrid who had ever eaten ramps," says Ledford.

Travelers from all over come to large ramp festivals that are annual events in many Southern Appalachian towns and communities. Volunteer fire departments and chambers of commerce organize these feasts to raise funds as well as to bring local residents and visitors together in celebration of Appalachian heritage.

For those who have never tasted the ramp, the festival offers a good introduction to it as a culinary delight. You will find it prepared in many different ways, so you can discover how you like yours best.

Don't be frightened by legends of the wild taste of the fiery ramp, or by tales that schoolmarms used to banish ramp eaters from their classes because of the lingering odor. Ramp mythology outruns the reality.

Enjoy the distinctive flavor of this mountain original, and thank Mother Nature for her bounty.

# WOOD FROGS

Under the bare hardwoods of the Roan, the sounds of the season have begun. Near standing pools of water, the shrill peeps of small green frogs are the dominant sound, but an undertone of lower quacks signals the presence of the wood frogs searching for mates. A sure sign of spring is the sound of these peepers and frogs wooing wherever water stands to give their eggs a safe place to develop. Long before mankind became a part of earth's family, these small amphibians flourished.

Today, in many places, the chorus is somewhat muted, as populations of frogs and toads have steadily declined over the past few decades. Researchers around the world are investigating the problem to determine the cause or causes.

Habitat destruction, ozone depletion with the increase of harmful ultraviolet rays, pollution, and acid rain are a few

*Three egg masses next to the red flag.*

of the factors that researchers have found which are destroying amphibians across the entire globe.

In the mountains of Western North Carolina, one biologist has recently begun a systematic look at the breeding habits of one of the most charming of mountain croakers, the wood frog *(Rana sylvatica sylvatica)*. One of the first frogs to open the spring chorus, the wood frog appears to be maintaining a strong population.

"I always check out ponds and things. As I was jogging on the track in the spring I'd hear the peepers calling. I thought I'd go down and check out the action," says Gene Spears, a biology professor at Lees-McRae College.

Between the track and the soccer field on campus he found a small wetland. In the shallow ponds, there were a number of large egg clusters. Spears had discovered a fertile breeding ground for the wood frog.

"I had already a lot of concern about the disappearance of frogs. The wood frogs were in pretty good shape, so I thought that maybe there was something about them that it would help to know," says Spears, as he pulls on his wading boots to check out his project.

This spring, he has developed a translocation experiment. The female wood frog tends to lay her egg mass, a large cluster of two to three thousand eggs, next to other egg masses. Spears is investigating whether the females are attracted to certain locations in the ponds or simply to other egg masses.

He put small yellow flags where he found an egg mass, then moved the egg mass to another location in the pond. There he planted a red flag. He then waited to see if the next females would lay next to the original site or beside the transplanted mass.

"In 17 out of 20 cases they laid them beside the other eggs," says Spears, as he slowly prowls the pond with his net and notebook.

The transparent eggs have a greenish cast. In the middle of each transparent ball is a small black dot, the embryonic frog. As it grows into a tadpole, it consumes the casing. In some places in the pond there are as many as 16 egg masses

*Gene Spears counts egg masses to record in notebook.*

clustered together.

"A big mass is warmer. By laying with other females' eggs, they're warmer and will develop faster," says Spears, as he squats down to examine closely one of the egg masses beneath a red flag.

"Originally, eight masses were over there," says Spears, pointing a few yards away to a yellow flag.

"I moved them over here. The next night there were eight more in this same spot," he says, nodding at the large gelatinous bulge next to the red flag.

While this year Spears has confined his controlled experiment to the wetlands at hand, he has been checking out other areas looking for the wood frog eggs. Wood frogs lay throughout the mountain region, requiring only a settled body of water.

Along Upper Creek, where in the past wood frogs laid in pools out of the main current, Spears looked this year. He found only clean basins, as heavy rainfall has caused floods which scoured the stream bed.

In addition to water problems, the wood frog suffers from predators such as ducks, crows, and bullfrogs.

"Crows and mallard ducks eat the tadpoles," says Spears. "Also, last year a big bullfrog moved into the pond below the track. After it was there awhile, there weren't any larvae left."

Spears is pleased with the progress of his frogs this year. The freezing weather has not appeared to harm the eggs, and the number of egg masses has increased since last year.

"So far, they all seem to be developing despite this nasty, cold weather. Last year, there were about 35 masses by the time the season was over. There are 40 this year, and I expect more to be laid," he says, as he looks over the bulrushes of the small ponds.

"Last year, I rescued endangered tadpoles; 'crisis intervention' I call it," he says, then smiles. "I do it for love of frogs."

Spears is pleased at the increase in his frog population. Last year's "crisis intervention," when he saved threatened tadpoles, appears to have paid off for him, increasing the sweet sounds of the frog chorus.

In most of the wetlands under Roan Mountain, the sound of muted quacking continues to proclaim the mating season for the wood frogs. Unlike the loud peeping of the small peepers, this deeper, quieter love song must be carefully listened for, but the rewards of careful observation such as Spears' is great.

When you see the large masses of eggs, do not disturb them. In a couple of weeks, the water will be full of small tadpoles beginning the hazardous process of growth and maturation. Watching this gradual metamorphosis into frogs has been a pastime for generations of children, linking them to the natural world.

Protection of frog habitats is one way to ensure this annual repetition of the spring chorus and the progression from egg to frog.

# MORELS

As the leaves gradually turn the winter-gray forest to spring-green, lurking among the vegetation beneath is one of the most eagerly hunted denizens of the Southern Appalachians—the morel mushroom. Known by a variety of names, from simply "the mushroom" to the more exotic "dry land fish," the morel has been a favorite of mountain folks for generations.

"I've gotten them all my life. We just called them mushrooms when I was a boy. We didn't call them morels," says Ted Ledford, who grew up on White Oak Creek outside Bakersville, North Carolina, and resides in Little Switzerland today.

"Some people called them dry land fish," he adds.

Ledford continues to gather the delicacy every spring, searching old orchards and other favorite spots which he does not wish to reveal. He seldom finds a surplus.

While eating wild mushrooms can be dangerous, because there exist many poisonous species, the morel is one of the most easily distinguishable mushrooms. It has a distinctive shape that sets it apart and is not mimicked by any poisonous varieties. Yet care must always be taken when gathering from the wild.

The morel has a cone-shaped head with ridges and pits. The size and shape vary from one kind of morel to another, but the general spongy appearance of the head is a tell-tale characteristic. The color ranges from white to blonde to yellow-orange to black, and the size from as small as the thumb to as large as a man's fist.

In some, the head predominates, while in others the stalk is long, with the head sitting as a cap on top. All varieties share a delicious taste when cooked. But the eating is only part of the lure of the morel.

Gathering the mushrooms takes you into the forest and fields at the most pleasant part of the year, springtime.

Before the trees have fully leafed out, the morel appears on the floor of hardwood forests or around older apple trees in aging and abandoned orchards.

The morel is an elusive quarry that requires well-developed hunting skills. The hunter must be extremely observant and steeped in the lore of the morel. Just strolling into the forest hoping to chance upon these mushrooms will leave you almost always disappointed.

While no rule is invariably accurate, there are some general guidelines that give the hunter a better chance of success. The season for searching runs from mid-April to late May and early June, depending on the elevation. In the woods or in an old apple orchard, turn your eyes to the ground.

First, you must be prepared to look carefully. Often, a morel hides under the new vegetation, such as the broad leaves of a May apple or the uncurling fronds of a fern, and sometimes conceals itself with the leaves from the preceding autumn. A raised lump in the leaf cover may be a mushroom.

Where you find one morel, there are often others hiding nearby. Careful scrutiny of the area may well uncover several more. With practice and experience extending over a number of years, you will gradually develop an understanding of the habits of the morel, although each year brings some surprises.

Often, morels will come up in the same places year after year, but sometimes reliable beds will fail to produce one mushroom in a particular year, or just give out forever. Spring rains will usually sprout the mushrooms, so hunting after a rainy day is best.

Once you have gathered a mess of the tasty fungi, cooking is easy, and eating a pleasure. First, slice the morels into pieces. This flattens them out and also allows you to check for ants and other insects that might be inside. According to some sources, the ants play an important part in the reproductive cycle of the mushrooms by carrying and burying the spores.

After the morel is sliced, some folks like to dip them in bat-

ter and fry the slices in cooking oil; others simply sauté them in butter, being careful not to drown them. Morels are good in sauces, soups, and other traditional mushroom dishes; however, they should not be eaten raw, but must be cooked.

Gourmets pay thirty dollars or more per pound for the succulent morels that are here for the finding and picking. Enjoy both the experience of the hunt and the flavor of the feast.

*Morels of various shapes and sizes grow in the Southern Appalachians.*

## SHORTIA

While hunters and entrepreneurs like Daniel Boone have received the bulk of attention as explorers of the Southern Appalachians, it was the work of botanists and other such gentle spirits that led to some of the most important discoveries in the region. Two men who have left an enduring legacy of exploration and discovery are Andre Michaux and Asa Gray. Michaux, a Frenchman who ranged the mountains in the late 1700s, and Gray, an American who led this country's botanical studies during the mid-1800s, are linked by a small flowering plant that became the most famous species in the Blue Ridge Mountains.

The story begins in 1788 when Michaux stopped to stay at the cabin of some Cherokee Indians. As he wrote: "I ran off to make some investigations. I gathered a new low woody plant, with saw-toothed leaves, creeping on the mountains at a short distance from the river."

He wrote in his journal "*aux clair de la lune* (by the moonlight)," giving explicit directions to the place in which he had found the plant. He took his discovery with him to Paris,

*Asa Gray*          *Andre Michaux*

along with a large number of such New World botanical wonders.

The next chapter of the tale takes place in 1839, half a century later, when the young American botanist Asa Gray visited Paris to examine Michaux's collection. He came upon an unusual plant, labeled "*hautes montagnes de Caroline* (the high mountains of Carolina)."

Gray wrote: "I have discovered a new genus, in Michaux's herbarium, at the end, among the *plantae ignotae*. It is from that great unknown region, the high mountains of North Carolina . . . I claim the right of a discoverer to affix the name. So I say, as this is a good North American genus and comes from near Kentucky, it shall be christened *Shortia*."

Dr. Charles Wilkins Short, for whom the plant was named, had corresponded with Gray for a number of years about their shared love, American plants. Short never saw the flower or the plant that was named in his honor, for he died in 1863, long before it was rediscovered.

The plant's full name was *Shortia galacifolia*, based on its resemblance to the common galax plant, as well as to honor

*Pages from Michaux's journal describing the shortia and its location.*

Short. Gray was confident that he could find living members of the species on his return to the United States. Since he had not found a specimen of the flower of the *Shortia*, he was especially eager to see it.

In 1840, Gray organized his first expedition to recover the beautiful lost plant that he had found dried out in the dusty bins of old Europe. He and his companions journeyed to the verdant wild forests of the Southern mountains in quest of the mysterious plant.

It eluded their search.

In 1843, he returned to scour the high mountains of the area. Grandfather, the Roan, Mount Mitchell, and other important peaks and ranges revealed their secrets to the assiduous botanist. Gray came upon the rare lily, later to bear his name, as he traversed the Roan, but he failed to find the *Shortia*, which was rapidly gaining a mythical reputation among botanists.

By the early 1870s, Gray had about given up. He wrote: "Year after year I have hunted for that plant! And I grew sorrowful at having named after Dr. Short a plant nobody could find. So conspicuous for its absence had this rarity become, that friends of ours botanizing in the mountains two years ago were accosted with the question—'Found *Shortia* yet?' from people who had seen our anxious search for it."

Ironically, Michaux had written in his journal directions to the place of his discovery that were as clear as the brilliant moonlight that had guided his hand as he made his journal entry. Whether Gray had read the journal remains uncertain, but he never came close to the site near the North Carolina-South Carolina border where the plant had been originally collected.

Michaux's reference to the "*haute montagnes* (high mountains)" appears to have misled the dedicated Gray. The glory of the discovery, or rediscovery, of the plant went to a 17-year-old boy from McDowell County, North Carolina. In May 1877, he found the rare plants growing on the banks of the Catawba River not far from Marion, the county seat.

George McQueen Hyams showed his specimens to his

*Shortia blossoms.*

father, an amateur botanist, who a year and a half later sent a sample to a friend in Rhode Island, who passed it on to Gray. The aging botanist was overjoyed at the vindication of his long quest.

"If you will come here I can show you what will delight your eyes and cure you of the skeptical spirit you used to have about *Shortia galacifolia*... Think of it! My long faith rewarded at last!" Gray wrote to a friend.

The aging botanist traveled from Boston to the Blue Ridge to see the wonder growing on the banks of the Catawba. He congratulated the young man, who had found what had eluded the searches of professionals, and was spurred on to resume his quest for the original site where Michaux had found the plant.

Since it was not the right season, he still had not seen the plant in bloom. He decided to explore the Carter and Unicoi County areas of Tennessee and the Mitchell, Avery, and Burke County mountains in North Carolina.

The 69-year-old Gray spent 20 days in 1879 traveling over

the Linville area and searching the Iron and Unaka Mountains ridge that separates Tennessee from North Carolina. His tramping through our local mountains over a hundred years ago left him as frustrated as had his earlier hunts.

The final chapter of the mystery concludes in the last year of Gray's life. A search party led by Charles Sprague Sargent, a Harvard professor, carefully followed the directions left almost a century before by Michaux. Near the Horse Pasture River in the Toxaway area of the North-South Carolina border, the searchers followed a "little path formed by Indian hunters," as Michaux described it.

They came upon a large bed of *Shortia*. The original site was rediscovered. The following spring a box of the blossoming plants was sent to Asa Gray. He wept with joy at the sight of the delicate, white, veined bells nodding above the deep green of the glossy, scalloped leaves.

The story was complete. The famous botanist could now die in peace on January 30, 1888, a century and a month after Michaux's original discovery.

Today the *Shortia* is a protected, endangered species. It is found in the wild at the two sites where it was discovered during the search, as well as a few more places, such as the Linville Gorge, near where Gray at one time searched. Also, collection and sales of the plant have spread it into other areas.

The Gardens of the Blue Ridge in Pineola, North Carolina, sells registered *Shortia galacifolia* plants under government control. For information, call (828) 733-2417.

## DOGWOOD BLIGHT

In the past, mountain forests would glow with the ghostly presence of dogwood trees during the spring. While the larger hardwoods held only the first hints of their foliage, the explosions of creamy white blossoms lit the forest understory in a joyful burst of beauty.

Today, mountain forests look very different. Where the glorious blossoming dogwoods once flourished, dead gray trunks rise starkly, or fall sadly, amidst the sturdy boles of oaks, poplars, and other trees. In little more than ten years, a virulent blight has attacked dogwoods throughout the Southern Appalachians, rendering many wooded areas barren of the blossoms that made spring a special time for lovers of natural beauty.

Dogwood *anthracnose* was first reported in the United States in the late 1970s. Caused by the fungus described and identified as *Discula destructiva* in 1991, this disease has ravaged much of the Appalachian chain from Massachusetts to Georgia. Although there are differences of opinion as to its origin, many botanists believe the disease was imported

*Healthy dogwood blossoms on a tree on the edge of woods.*

into the country on Japanese dogwoods.

"It was found initially in the New York-Connecticut area in 1976-1977 and also found in Seattle in 1975-1976. It attacked all members of the flowering dogwood. The native species has almost no resistance.

"The Japanese dogwood has resistance. The blight has spread rapidly. All of this suggests an introduced pathogen," says Larry Grand, a professor in the plant pathology department of North Carolina State University.

*Dead dogwoods in the woods.*

Flowering dogwoods (*Cornus florida*) and the Pacific dogwoods (*Cornus nuttallii*) are highly susceptible to the fungus, while the imported Kousa dogwood (*Cornus kousa*) is resistant, but can serve as a host.

In 1987 dogwood *anthracnose* was first discovered in the South in Georgia. Since then, its spread has been rapid, with varying degrees of mortality reported. Some areas have lost virtually all the dogwoods in the forests; others have suffered relatively light damage. Many homeowners also have suffered the loss of their favorite ornamental trees, while others have been able to protect their dogwoods by following guidelines established by plant pathologists.

Elevation plays an important role in the progress of the disease. Distribution maps identifying confirmed cases of infection show it clustered in the mountainous counties,

although there are some outbreaks in the lowlands.

"There's a definite relationship to altitude in our state. The plant doesn't grow above 4,000 feet, and the disease is very seldom seen below 2,400 feet. There is a notable exception in Dare County (on the coast), and there is an active site on the James River in Virginia," says Grand, who has studied the problem for several years.

Moisture and cool-to-moderate temperatures facilitate the spread of the fungus, thus it thrives in the cool, moist woods of the Southern Appalachians. The higher altitude dogwoods are the first to die. It is difficult to find a thriving tree in the woods in the high elevation counties, such as Mitchell County.

The forest dogwoods must fend for themselves. This means that most will succumb to the disease. But dogwoods in suburbia or in mountain folks' lawns have a good chance of survival. Being in the open allows them to receive the beneficial rays of the sun, which combat the fungus.

Alan Windham of the University of Tennessee's agricultural extension service has reported that trees in sunny locations appear to be surviving well.

"Trees in heavy shade and near water are much more susceptible than trees in full sun with foliage that dries off each morning," he says.

The future of dogwoods remains unclear. Some experts predict near extinction, others see the tree returning to its glory days as dogwoods resistant to the fungus proliferate.

Charles Little, in his book, *The Dying of the Trees: The Pandemic in American Forests,* presents a gloomy picture, showing little hope for the beautiful tree. He sees its death as a warning that other species may soon follow as the environment continues to degrade.

"Is the lovely dogwood, a tree without major economic importance, sending us a sign, a warning, as its last gift before it disappears altogether?" he asks near the end of his chapter on the dogwood's decline.

Larry Grand, who annually drives through some of North Carolina's mountain counties to survey the year's bloom,

believes that the situation is not hopeless.

"A few selections of *Cornus florida* appear to have some resistance. The disease has killed off the weakest trees, but the worst may have passed. The distribution map for this year looks much the same as last," he says.

Hope is strong for the dogwoods in people's yards. Often, care can maintain their health. But it will be many years before the woods again wear the soft beauty of widespread blossoming of the dogwood in the spring, and many woodland birds and animals will face hungry days in the fall without the bountiful supply of the red berries.

Identifying the symptoms of dogwood *anthracnose* can help you combat its effects on your trees.

In the spring, the bracts (the four white or pink petals that surround the small blossom of the plant) may become spotted or blighted, particularly if heavy rains fall during blossoming, a situation which we often face.

Later, the leaves may show tan spots or have purple rims. Also, small holes may appear and, eventually, the leaves may die prematurely.

Twigs can develop canker spots, and as they die, the tree sends out water sprouts or epicormic shoots from the lower trunk. These are prone to infection, which will pass from

*Epicormic shoots on a diseased tree.*

them to the main stem, eventually leading to the death of the tree.

Jeff Vance of the Mitchell County Agricultural Extension Service has been dealing with the growing problem of the dogwood blight for the past few years.

"It seems like it just keeps getting worse each year. In the past three or four years a lot of people have been noticing it. Most of the people are calling in here for information about what to do with the ones in their yards.

"It's kind of hard to control, because of the ones in the woods. It's hard to keep it from affecting the ones in the yard," he says.

When planting a dogwood, put it where it will get open sunshine to combat the fungus. Also, the more open to circulation of air, the better your tree will do.

To protect dogwoods, water the roots during periods of drought, but avoid getting the leaves wet. Fertilize moderately in the spring, but do not apply excessive nitrogen. Avoid any damage to the trunk, such as that caused by bumping with lawnmowers.

If you detect signs of *anthracnose*, prune and dispose of any diseased twigs and branches. Also, rake up any fallen leaves and remove them from the vicinity of the tree. If your tree begins to put out water sprouts, remove them as they appear.

In some instances, the application of a fungicide may be helpful. Contact your county extension agent for information about effective fungicides and how to safely apply them.

# BIG BUTT TRAIL

While thousands of folks walk the trails along the Black Mountains through Mount Mitchell State Park, far fewer make the trek along the western, fishhook section of the Black Mountain Range.

Beginning at Balsam Gap at milepost 359.8 of the Blue Ridge Parkway, Big Butt Trail travels the crest of the ridge that roughly parallels the more famous ridge that is the home of Mount Mitchell. This simple footpath runs the length of the ridge from Balsam Gap to Cane River Gap, a distance of about six miles, and it requires some fairly strenuous hiking.

The trailhead lies beside the Balsam Gap Overlook. Park your car at the overlook and walk slightly downhill to the left from the parking area. The trail sign is missing, so be sure to avoid taking an old, overgrown road that leaves from the middle of the area.

The trail to Big Butt runs through a variety of vegetation and across different land forms. At times you climb steeply through rocky cliffs, at others you stroll through enchanting glades full of emerald grasses, blossoming flowers, and tall trees.

*Hikers enjoy painted trillium blossom beside the trail.*

You begin the trek by descending along a narrow trail surrounded at this season by brilliant red, wake robin trillium and masses of false Solomon's seal with its nodding plume of flowers. Soon you climb into the spruce-fir forest, where large red spruce and Fraser fir have defied the debilitating environmental attacks that have reduced the stands on Mount Mitchell to bleaching silver stalks.

Along the trail, painted trillium nod their red and white flowers, patches of bluets cheer your climb, and wild cherry blossoms rain down when the wind blows. At different seasons you will find differing vegetation capturing your attention, but at this late spring time the flowers on the forest floor are captivating. Chickweed, mayflowers, May apple, blue bead lilies, and other varieties continually attract your attention. Also, flowering bushes and trees, such as dog hobble, elderberry, hawthorns, cherries, and mountain ash show their white blossoms.

Large trees grow along the trail through most of its course. Maples, yellow birch, wild cherry, ash, beech, and other hardwoods, as well as the red spruce and Fraser fir provide shade as well as their own beauty. Strong winds, below zero temperatures, and heavy snow and ice that make the ridgetop environment harsh have twisted some of the maples and birches into tortured shapes and have brought down many trees of all kinds.

Some have been snapped off; others lie uprooted, their widespread networks of roots showing how shallow the soil is in places. Although the trail is maintained, in some places you will find logs across the narrow path that must be climbed, and in others, large trunks hanging overhead that you must pass under.

You will also have to pass though blackberry and raspberry patches, but because of the high elevation of the trail, which stays over 5,000 feet most its length, these are the thornless varieties. Butterflies, ladybugs, and other insects crawl about the plants, enjoying the nectar or other bugs, while bees buzz among the blossoms

Many small birds enliven your walk. Juncoes, warblers,

thrushes, and other songbirds make sweet music and flit about from the forest floor to the high crown.

Bursting from the undergrowth, ruffed grouse hens with their chicks may startle you. The mother creates a spectacle to capture your attention, then leads you down the path away from her young. The tiny chicks hide under leaves and other cover, waiting for their mother to return and call them back to her protection. If you look carefully, you might find one of the yellow and brown balls of feather huddled in hiding.

*The trail winds through glade.*

You will hear the raucous croaks of ravens, the piercing screams of hawks, and the melancholy hoots of owls, and from open overlooks you may see the majestic red-tailed hawks riding the currents or stooping in breathtaking dives from the clouds.

White-tailed deer make the mountain their home. They browse in the glades, enjoying the succulent grasses. If you walk quietly, you may come upon the shy creatures as they feed.

For most of the trail, the thickness of the woods prevents your clear view of the parallel ridge with its famous peaks, but you can glimpse through the trees and shrubs parts of the ridge. However, after walking about two-and-a-half miles and climbing a steep, rocky trail to Little Butt, you can find openings that reveal the mountain range and the valley beneath in all its grandeur.

The Big Butt Trail can take you into the past as well as into the forest. In 1835 the famous explorer and professor Elisha Mitchell hiked to this high ridge to try to determine which of the Black Mountains was the highest peak.

You can appreciate his difficulty as you scan the long range with one peak after another undulating along its length. On a cloudy day recently, the clouds told the story, as the last peak to be uncovered by the clouds as they lifted was Mount Mitchell.

Professor Mitchell approached his task in an orderly, scientific manner. Preparing for this journey, the famous explorer and professor from the University of North Carolina noted his hopes for the trip: "Objects of attention—Geology; Botany, Height of the Mountains; Positions by Trigonometry; Woods, as of the Fir, Spruce, Magnolia, Birch; Fish, especially Trout; Springs; Biography, &c."

He took along with him "Two barometers, a Quadrant, a Vasculum for plants, and a hammer for rocks." The barometers were important in his quest to determine the heights of the mountains, because he used these to measure the air pressure and mathematically determine the elevations of the various mountains according to the readings.

Mitchell spent a week in the Black Mountains. He first climbed Celo

*Tall trees disappear into the clouds and mist above the trail.*

Knob, at the far northeastern end of the Blacks. From there he determined that peaks further south along the main ridge were higher than Celo. He descended the mountain and found a guide in Samuel Austin, who lived near the confluence of the Cane River and the Cattail Creek, located in the middle of the valley enclosed by the fishhook-shaped range of the Black Mountains.

Guided by Austin and a neighbor, William Wilson, Mitchell ascended the shorter, western ridge to a peak that would give him a clear view of the long ridge with all of its peaks. Called Yeates Knob at that time, the peak was probably part of what is known as the Big Butt section today.

From that vantage point, Mitchell scanned the Blacks but was still uncertain. As he wrote, "It is a matter of considerable difficulty, in the case of a long ridge like this, that swells here and there into a knob two or three hundred feet higher than its neighbors, to ascertain which it is that overtops the rest, from our inability to determine how much of the apparent elevation of one, amongst a number, is due to its nearness, & how much to height."

Although uncertain, Mitchell did choose the correct peak to explore further, and the next day climbed to the top of what is now known as Mount Mitchell. He took measurements to determine its height. With that, he determined that he had found the highest peak in the East.

This feat ensured his lasting fame, but also brought about a controversy that led to his death over two decades later, when he returned to the scene to prove his claims against those of his rival, Thomas Clingman.

You can walk in Mitchell's footsteps by hiking the Big Butt Trail. The Big Butt Trail offers a stimulating hike, an immersion in the high elevation environment of the highest chain of mountains east of the Mississippi River, and a taste of history. As with any hike in the high mountains, the temperature can drop to dangerously low levels even in summer, so dress in layers and bring a warm jacket.

# GARDENS OF THE BLUE RIDGE

Spring is a time of renewal. For the folks at the Gardens of the Blue Ridge, the oldest licensed plant nursery in North Carolina, it is always a special time. In this decade more than ever, the spirit of the season animates this family-run business that specializes in wildflowers.

Over a hundred years ago, E. C. Robbins bought out his partner, S. T. Kelsey, and since the early 1890s the Gardens of the Blue Ridge have remained in the hands of his family. Today, members of the third and fourth generations run the business, but in the past year major changes have taken place.

The death of Edward P. Robbins, the son of the founder, in 1991 left the business to a number of heirs. His daughter Katy Robbins Fletcher, her husband, Paul, and sons Eddie and Robyn bought out the others in May of 1992, but as a result had to move to another site where land was less expensive.

In July 1993 the Fletchers made the move to just inside the Burke County line on Highway 181. Transplanting not just the business offices but also 10.5 acres of wildflowers and shrubs was an enormous undertaking with great risks. People and plants are still dealing with the shock.

"It was hard to do," says Paul Fletcher, shaking his head at the memory.

"Physically, emotionally, and all, it was very hard on all of us," says Katy.

"It took a lot of work to get these beds in, about seven different operations. We had to clear it, plow it, disc it, etc.," says Paul, pointing to the raised flower beds that stretch across the field near the central building.

Eddie, who worked with his grandfather for 18 years, and Robyn, who worked 14 years, are the botanists of the family. Eddie studied at nearby Lees-McRae College and Appalachian State, earning a degree in earth sciences. He

*Robyn Fletcher and a bed of ferns in shade of tree.*

no longer works at The Gardens. Robyn learned botany at Dekalb Junior College in Atlanta.

In addition to their formal education, they have accumulated years of practical experience in dealing with Southern Appalachian wild plants. They are acknowledged experts whose opinions are sought and valued by amateurs and professionals alike.

One semester they took a course in plant propagation at Mayland Technical College. They were invited back to teach the course the next semester.

Each day they assess the state of the plants they have transplanted in the new beds. Some are thriving, but others are in a sad state.

One disappointment has been the *Shortia*, also known as

Oconee bells. This rare perennial is found in only a few places in the mountains of Western North Carolina, South Carolina, and Georgia. The plants in the new beds are withered and brown.

"Yeah, this is the *Shortia*. It just burned up. The roots are probably all right, but we'll see," says Robyn, as he looks down on plants that should be deep green and flourishing at this season.

Fortunately, the family left some of the rare stock in moister beds elsewhere, and will be able to propagate the plant from the surviving members of the species.

Some other rare plants had similar problems caused by the forced removal from established sites.

"The ginseng roots all rotted, too," says Robyn. "We dug it in the middle of the summer and shocked it."

A nearby bed of *trillium grandiflorum* presents a study in contrast to the sad looking *Shortia*. Thousands of plants, each with its snowy blossom, sway gently in the breeze. Robyn kneels to inspect them with a smile on his face.

"In the next month, most of these beds will be full of flowers, we hope," he says, as he looks at the green shoots emerging from the ground.

Despite the trauma that most of the plants experienced, spring works its magic throughout the gardens.

Some wildflowers native to the new site have already emerged from their home ground. Small clumps of bluets bring a blue note of cheer to the area. The light pink *punktatem rhododendron* blossoms fill the shrubs that are scattered about the acreage.

From a planting bucket an unusual jack-in-the-pulpit stands erect.

"Last year I noticed that it had a third leaf. I'd never seen that before, so I wanted to see what would happen this spring. It came up with the extra leaf again," says Robyn, picking the plant up to show its special character.

While Robyn and Eddie tend to the plants, their parents help the customers who have found their way to the nursery's new home. Although there is never a crowd, a steady

*Paul Fletcher bends to inspect a healthy clump of shortia.*

stream of wildflower aficionados flows through the gardens to admire and to buy.

"We're more and more encouraging a walk-in business, although we're basically a mail-order business. Ninety percent of our business is mail-order," says Paul, as he leads the way to the shipping room.

"It's always been a native shrubbery, wildflowers, and trees nursery. Her grandfather used to ship by rail back in the 1920s. There was a shipping station down on the railroad," he says.

"A major portion of the business was wholesale back then," says Katy, stopping to point to a large map of the world mounted on the wall of the shipping room. Small black-

headed pins dot the map.

"That's where we ship to. Even over here in Tasmania. It's really tough shipping to other countries. There's so much red tape," she says, as she points out the cluster of pins in Europe, then moves her finger to the downunder island of Tasmania.

At a table nearby, Teresa Voorhees and Robyn work on the day's orders. They wrap the plants in moss to hold moisture and enclose a brochure on how to plant the herbs. Endangered species must have a protected plant permit tag.

A rare goldenseal is carefully prepared for shipping. A commerce tag, invoice, planting instructions, and catalog will accompany it on its journey in a sturdy cardboard box. Years of experience help ensure its arrival in good condition.

The Fletchers are quick to point out that the plants they sell are not dug in the wild but are propagated at the nursery. Robyn and Eddie respect the wildflowers that are their love as well as their livelihood.

"Except for those that we dig in places that are going to be logged or bulldozed, we grow here. We do dig some before growers spray their Christmas tree plots; they call us to let us know," says Robyn.

"We don't have time to botanize in the woods anymore. We used to for our own pleasure, but we just have so much to do," he says, looking out over the new fields blossoming under the spring sun.

It's a new season for the Gardens of the Blue Ridge. For information, write Gardens of the Blue Ridge, Box 10, Pineola, NC 28662 or call (828) 733-2417.

Eddie Fletcher no longer works at The Gardens of the Blue Ridge.

# WILD STRAWBERRIES

A treasure lies hidden right out in the open throughout the mountains from late spring to mid-summer. Bright red jewels, wild strawberries, dot many old pastures and other open spaces in the Southern Appalachians.

From late May through August you can find the small red nuggets of sweetness. While snow and ice still cover the highest peaks, the white flowers of the wild strawberry dot the pastures and fields of the valleys. Throughout the spring and summer, the cheerful blossoms climb the mountainsides as the red fruit replaces them lower down.

Strawberries are rich in iron, potassium, calcium, sodium, sulphur, silicon, malic, and citric acids, providing a good source of vitamin C. Their early appearance in the growing season makes them especially welcome.

Overshadowed today by the bigger, more abundant, and more easily gathered cultivated strawberries, these small nuggets of sweetness are often left to the birds, field mice, and insects. But in times past, the wild variety was *the* berry

*Wild strawberries hide in the pasture grass.*

to gather for early summer fruit.

Many of the graying members of the older generation of mountain folks remember gathering the wild berries as children.

"That's all people had back then—was wild strawberries. Wasn't no such thing as tame," says Mary Burleson, resting in the cool of the evening after working in her garden near where Rock Creek and Greasy Creek run together, in the Buladean Community of Mitchell County.

"Lord have mercy, me and my mama used to pick wild strawberries all the time this season. It seemed I never could get my bucket full, but my mama sure could. Me and my mama used to can a hundred cans a year of them," she says, her eyes sparkling with the memory of the gathering and the canning back in the 1930s.

While Mary can't remember well when she stopped gathering the wild fruit, she knows it was years and years ago, when people started growing the cultivated varieties. But she recalls her neighbor, Pauline Street, gathering them as late as the 1970s and early 80s.

"Lord, Pauline used to go up there and pick buckets and buckets full every spring. You go see her," says Mary, gesturing up Greasy Creek Road.

Pauline Street is confined to a wheelchair these days, but while her body is restricted, her mind runs easily over the mountains she used to roam. Sitting in the doorway of her house, she points across the road to a patch of pasture high on the hillside.

"Law, I used to pick up there in that pasture. There used to be a plenty of them. Sometimes I'd get a peck bucketful, sometimes a gallon bucketful," says Pauline, letting her eyes travel where her feet used to take her.

"I liked them of a morning with my bacon and eggs. I'd put them on my bread like jam," she says, smacking her lips at the memory.

For Pauline, preserving the fruit for the winter was easy; she sprinkled them with sugar and put them up in her freezer. Today she does the same thing with the cultivated

*Blanche, Pam, and Mitchell Joslin pick berries.*

berries she buys by the gallon, but it's just not the same.

"Wild strawberries are better than tame strawberries," she says, shaking her head. "Law, they used to be as big as tame strawberries, too."

Elizabeth Audet, transplanted to the mountains of Western North Carolina from Maine, remembers a time when she had both the time and the patience to gather the delectable morsels.

"When I was pregnant, my mother-in-law and I would pick strawberries in an old pasture. I could crawl around on the ground and pick and pick. I wanted to get every one of them.

"I love them. Their flavor is so much sweeter than the cultivated, so much more flavor. It was hard to leave the patch," she says, thinking back to 40 years ago.

"At night I used to dream I was in a big field of strawberries. I couldn't stop picking them. I saw berries and berries and berries surrounding me," Elizabeth adds, recalling how the hours spent in the fields would invade her sleep at night.

She made a nutritious drink from part of her berries—

strawberry shrub.

"We'd take a quarter cup of berries and mash it up in a glass, add sugar and fill it with water," she says.

Or she'd make the mountain favorite, strawberry shortcake.

"We'd used biscuits. We'd cut them in half and add butter. Then put mashed strawberries over them and pour on a little milk, not much, just enough to moisten it," she says, patting her stomach at the memory.

Most folks today don't have the patience to pursue the wild berries, which are delicious but generally smaller than the cultivated ones. Yet patches still flourish in the early springtime with the small white flowers that precede the bright red fruit.

If you remember seeing the strawberries' spring blossoms, take a bowl (a bucket is too intimidating) with you into a mountain field and look carefully under tall grasses, daisies, and other field flowers. You will find the sweet jewels growing in clusters, if the robins haven't beaten you to them.

If you eat a few as you gather the berries, it might take you awhile to fill your bowl, but the work environment is a pleasant one, and the reward is sweet.

My family enjoys picking and eating the fruit, but we find it difficult to amass the pecks and gallons former generations collected for cooking, preserving, and making jellies and jams. These days, more of the small berries disappear into the mouth than go into the collecting sieve.

Lurking at the base of their distinctive sawtoothed leaves, the berry clusters are easily spotted once you get down on their level. Even the largest of the wild strawberries are smaller than their average tame cousins, so it takes a large number of the untamed ones to fill even a small bucket.

Unfortunately, seldom are all the berries in a single cluster ripe at the same time. Sometimes you will find a flower on the same plant that holds a deep red ripe berry, as well as other berries in varying shades of ripeness from white to pink. It takes patience to select only those ready for eating.

Of course the main reason for picking is the eating. The berries that survive the pickers in my family find themselves

poured over ice cream or covered with milk and sprinkled with sugar.

The children can hardly endure the task of capping the berries, the tedious plucking of the small hulls at the top of the fruit, and often part of the harvest disappears into the mouths of the cappers. After all, the easiest way to remove the hull is to bite the berry from it.

The rewards of picking wild strawberries should not be measured by efficiency experts or with a time clock. They are part nostalgia and part sensual, simple but satisfying. And the work environment is unmatched for beauty and calm.

## EARLY APPLES

Most people consider the apple to be a fall fruit. But there are exceptions, sweet exceptions, that bring a smile to fruit lovers' faces, tasty bites to their mouths, and delicious pies to their tables.

In the Southern Appalachians the Yellow Transparent is the favorite early apple. Apple-starved mountain folks can take their first bites in late June when the green fruit has a tart taste and a crispy crunch. By late July, that early greenness has mellowed to a sweet yellow, with flesh that melts in the mouth.

According to Chreighton Lee Calhoun, Jr. in his 1995 book, *Old Southern Apples*, this apple was imported by the USDA into the United States from St. Petersburg, Russia, in 1870. Throughout the mountains, the Yellow Transparent continues to thrive in orchards large and small.

In the late years of the 1990s, Lee Hughes was still climbing into tall trees to harvest the crop of Transparents to sell to folks coming to his family's blueberry patch. Undaunted by the height of the tree or his 89 years in 1998, Lee brought down six half-bushel baskets. He has been in the apple busi-

*Striped sheepnose apples ripen at Lee Hughes's orchard.*

ness for as long as he can remember, harvesting from heirloom trees.

"My father, Dave Hughes, planted that before I was born. Lord, I don't know when. Anyway, that's an old tree. I clumb that 20-foot ladder way up into it," said Lee, who slowly climbed up the ladder again to get an apple or two he had missed.

On the ladder, he pointed to a small branch holding some walnut-sized apples.

"See those seedlers, they're the apples that the tree naturally grows. The Transparents was grafted on by my daddy," he said, pointing out the differences between the small fruit and the more-than-fist-sized Transparents.

Lee's wife, Vergie, climbed onto a four-wheeler to drive a load of the apples to sell on her daughter's farm. The baskets were filled with the bright yellow fruit.

"Transparents are good to eat," she said. "And they make the best apple pie."

After she drove off, Lee led the way to a small tree that he grafted this spring with scions of his father's Yellow Transparent tree.

"See, the grafts is already three feet long," he said, stooping to point to the place where he inserted the sprigs into the sawed-off stem of the small tree and then covered the joint with grafting wax.

"Next spring, I'll saw all this off and just leave the Transparents," he said, then pointed to the large trees in his extensive old orchard. "A lot of these old trees—you can still see the line where they were grafted."

Across the county at the Orchard at Altapass, folks have been buying the Transparents when they stop off the Blue Ridge Parkway. The 1998 crop was exceptionally good.

"Each summer when they come out we're always kind of surprised. This is our best year ever for Transparents. They're the prettiest we've ever had. They come in about the 4th of July and last through the month," said Judy Carson, one of the partners who run the orchard, pointing to the crates filled with large yellow apples.

One of her assistants, Ann Kernahan, said that many of the Southerners who stop to visit at the orchard are familiar with the Transparent, as are most of the local people. Everyone has a favorite way to prepare them.

"We've made pies with them and applesauce. Also, they freeze very well," said Judy Carson, picking up one of the large golden apples.

Another early apple that was ripening at the Orchard at Altapass is not as common as the Transparent, although in the past it was much more widespread. The Carolina Red June, for hundred of years, was an early favorite. According to Calhoun, "For almost two centuries, Carolina Red June was the early apple of choice for most Southerners."

*Vergie Hughes dirves her apples to sell at her daughter's berry patch.*

A bounty of reddening apples covered several of these trees at the Orchard at Altapass. Drop apples lay hidden in the grass beneath the trees.

"Several things worked together to make Carolina Red June one of the most important Southern apples well into the twentieth century. The fruit begins ripening very early, continues ripening for over a month or so, and has good taste and texture for an early apple," writes Calhoun in his book.

Today there are few of these apple trees left bearing. Time and indifference have brought most Carolina Red June trees to decay in the mountains.

"Everybody's has just about died out. They used to grow

everywhere, but they just got away from us. I'm going to graft one next spring; my sister has one," said Lee Hughes.

He does have a few trees of the Striped Sheepnose that are just coming ripe now. The oblong fruit, pointed at the blossom end, are red apples with a good taste.

"The Striped Sheepnose is an early apple. They come in just when the Transparents get gone. They're good to eat and cook," said Lee, pointing to one bright red apple on a large tree covered with ripening fruit.

Calhoun discusses a summer apple named Sheepnose in his book, saying, "This apple is probably extinct."

He quotes from Virginia Nurseries that advertised this apple from 1910 to 1928, "We have fruited it for several years and pronounce it the best eating apple we have seen for August. Fruit large at the base, tapering to the apex, covered with brown russet red. Tender and fine. Tree rather a crooked grower; said to live to a great age."

An alternative, also believed by Calhoun to be extinct, is a Striped apple listed by Smith's Nursery of Franklin, Tennessee, in 1893, "From Wilson County, Tennessee. Tree a fine grower; fruit medium to large, bright red on yellow; flesh yellowish, rich, subacid, very firm and high flavored. An excellent bearer. July 5th to 20th."

Besides good eating, these early apples provide interesting material for research. They are a living heritage, dependent on us for their continuation. These heritage varieties cannot be grown from seed, so without man's care and husbandry, they will subside into memory, as many varieties of apple already have.

Commercial orchards no longer grow these varieties, so it is up to individuals to keep them a part of our Appalachian culture.

# ROYAL PAULOWNIA

For the past couple of years, folks driving past A.D. Harrell's farm between Red Hill and Tipton Hill have noticed small groves of strange trees rising heavenward next to the road. In this summer season, the exotic-looking tall trees have leaves as big as elephant ears.

Their story is as exotic as their appearance. These Royal Paulownia trees are native to China and Japan. Known as the empress tree and the princess tree, the Paulownia is named for Princess Anna Paulowna, daughter of Czar Paul I of Russia. For centuries in Japan, the right to grow the tree belonged solely to the royal family.

Both the beauty and the utility of Paulownia make it a royal tree, but its extraordinary worth is what attracted A.D. Harrell's attention.

"I taught high school agriculture 20 years ago. In doing some research in that work, I found an account that one of these trees, before it was cut down, brought $30,000. I made a little note of that, and some 15 years later, when I had time, I decided to do something with it," says Harrell, a lifelong resident of Mitchell County.

"If you know A.D., you know that those figures will keep a'twirling," says his wife, Geneva, then laughs.

Harrell started his

*A.D. Harrell checks the circumference of one of his Royal Paulownia trees.*

— 43 —

experiments with Paulownia by ordering some seedlings from Carolina Pacific International, Inc. These were *Paulownia elongata.* He put them out and has carefully tended them to ensure a straight trunk clear of limbs. But he has doubts about the variety.

"I ordered a hundred seedlings—*elongata.* But I've abandoned those already. I have some big trees, but they're just not satisfactory here. I decided to try the *tomentosa* variety," says Harrell, leafing through the literature he has gathered on the subject.

So he began to search for a tree of the *Paulownia tomentosa* variety growing in the mountains. Although the trees are not native to this region, they have been growing in the mountains for well over a hundred years. One of the famous stories of plant mysteries in Western North Carolina concerns the Royal Paulownia.

On a spring day in the late 1870s, Giles Pearson, a mountain boy, exploring along the Pacelot River, noticed a strange looking tree with clusters of violet-blue blossoms. Although familiar with local vegetation, he was unable to identify the unusual tree. He broke a branch to take home to his parents, who also were baffled by the beautiful blossoms.

Twenty years later, when a botanist from Brown University came to the area to research the native plants, he engaged Giles Pearson as a guide. On one of their treks through the mountains, Giles pointed out the tree that had stumped the local folks for years.

The botanist immediately identified the tree as the Paulownia. He had studied the species in Japan, its native habitat. How the tree had found its way into the mountains remains a mystery. Some folks say that three outlanders hiking in the gorge stuck their hiking sticks in the ground as they left, and these took root.

There is also the possibility that Paulownia seeds found their way into the mountains as packing material for fine porcelain, imported from China. The Chinese often used the tiny, fluffy seeds of the tree to pack fragile goods. However they made their way into the rich soil of the Southern

Appalachians, Royal Paulownia trees thrive in many sites.

So A.D. Harrell set out to find a strong tree to be the foundation of his stock.

"Fall of 1994 I looked wherever I traveled for a tree to get seed. I found one on the far side of Gillespie Gap on the right side of the road as you go down. I decided to get seed there because the tree looked good and was on the mountain," he says, opening a paper sack to show the tiny seeds of the plant.

After blossoming, the tree produces pods that are filled with the seeds, approximately 2,000 per pod, with each tree holding many pods. Harrell pulled a limb full of pods from the tree he found and harvested the seeds.

*A.D. Harrell shows Mitchell, Dylan, and Blanche Joslin Royal Paulownia leaves as large as elephant ears.*

Harrell germinates the seeds and starts his young plants in his tobacco bed, where he saves them a ten-foot section. Paulownia, which has difficulty competing with the thick natural vegetation, thrives in the clean soil of the tobacco bed. And once he places the young trees in the soil, they shoot up.

One of the attractions of the plant is its rapid growth. On his farm, Harrell has some trees that have reached impressive size in only four years. The larger trees have reached a circumference of 30 inches in that time, and they tower overhead. In one plantation, a number lost large limbs in a fierce thunderstorm, but the main stems remain strong.

He has seven plantations of Royal Paulownia scattered

across his various pieces of property in Mitchell County. He hopes that if he has enough trees thriving, he will attract the attention of the timber industry in the area.

Across the country, more and more people have taken an interest in the tree. Harrell belongs to the American Paulownia Association, which publishes a newsletter to inform its members of the wonders of the Paulownia. One of its chief attractions is its beauty and workability, combined with its light weight.

In his barn, Harrell has some boards he has sawn from his young trees. The wood is strong, attractive, and unbelievably light. A cubic foot weighs 14 to 18 pounds, compared to the 60-to-70 pound weight of conventional hardwood. Lumber from Paulownia trees is highly sought after in Japan, where it is used for fine furniture, chests, and musical instruments.

Paulownia logs are so valuable that tree rustling is a common crime in areas where the trees have established themselves. News reports in the past decade have covered such crimes in Virginia and Maryland, as well as in North Carolina, where tree thieves cut and tried to steal logs in the Nantahala National Forest.

"The Forest Service found the logs before they could get them out. There were 16 logs. They solicited bids, and I know that $32,000 didn't get them. They went for more than that," says Harrell, his eyes gleaming.

He works hard to get his Paulownia stands in good shape. He loves the beauty of the trees as they shape under his nurturing, but the reward at the end of the project is never far from his thoughts as he trims the branches to ensure a straight, tall stem.

"I'm gambling that in a few years it will be a strong financial project. As for now, there's no established market for these trees around here, but it has such superior qualities, I think it will go. I really do," he says, standing in the shade of the big leaves of the high-crowned Royal Paulownia.

## HEMLOCK HILL

Few areas of virgin forest remain in the Southern Appalachians. For many years, folks were more concerned with removing timber than preserving it, and by the time they realized what they had lost, the great primeval woods had disappeared forever.

Yet patches remain to tell of its glory.

Seventy-five years ago, a mountain institution and a generous nature lover joined together to purchase for preservation twenty acres of virgin forest in Banner Elk. In its quarterly newsletter, *The Pinnacles*, Lees-McRae Institute appealed to its supporters to help save this irreplaceable natural wonder:

"For years the ravaging sawtooth has ground its way into the very heart of great trees brought down from nearby hillsides. A few scrubby bushes, a pile of sawdust—these remain to tell the story of nature's rule over the hills," began the appeal, which went on to describe a piece of property,

*Lees-McRae College President Earl Robinson (sweater) and Stewart Skeate (in hat) lead students on a hike for Mountain Day.*

"densely wooded with virgin forest of hemlock, maple, and birch," that adjoined the school's grounds.

The article also mentioned that lumber companies were anxious to purchase the land for the timber, but that Lees-McRae had "secured an option good for sixty days on this wooded hillside."

This appeal touched the heart of J. M. Knox of Salisbury, North Carolina. He donated $1,000 to buy the forested hill for the school. In 1935, a plaque was erected to commemorate his investment that has paid dividends for several generations of students and staff at what has become Lees-McRae College over the course of the century.

Named Hemlock Hill for the evergreen trees that tower on the knob, the patch of virgin woods are important in many ways. The large trees remind us of the grandeur that once existed across the Southern Appalachians, and the twenty acres makes an excellent laboratory for the biology students at Lees-McRae.

"We use it quite often. We do measurements of the trees, count the number of trees for density, and study the forest composition, birds, and animals—do work on the overall natural history," says Dr. Stewart Skeate, a biology professor and director of the school's naturalist program.

While studying the forest, Skeate and his students have been able to compute the age of the trees on Hemlock Hill.

"We found one log of a small tree that had come down. It was 300 years old. By using geometry, we got an estimate of the larger trees. Some came out 580 years old, according to the formula," says Skeate, who has explored all over the preserve with his students.

One aspect that impresses botanists who visit the forest is the fact that hemlocks dominate the area.

"Hemlocks rarely are the naturally dominant species. It is pretty striking. There are almost no young trees. Some of the younger ones are 200 to 300 years old, so they will continue to dominate for a long time," says Skeate.

He has also discovered some bird species that normally live at higher elevations, such as golden crowned kinglets

*Millpond Waterfall's roar greets hikers at the bottom of the trail.*

and winter wrens, thriving in the dense hemlock forest.

Another scientist in the department, Dr. Ken Davis, is equally impressed with the college's own little patch of wilderness. He explores the woods, and also works to maintain the hiking trail that runs through the forest.

With his colleague Dr. John Keener, Davis hiked up the path on a June day. At the lower end, a large rock had been placed to prevent vehicles from entering. The continuous, muted roar of the millpond's waterfall provided a background for birdsong. Climbing up the trail's side to dig into the forest floor, Davis brought down a handful of the rich soil.

"If you pinch up the soil here, you can see what a high organic content it has. The soil scientist who tested it during the Avery County soil survey was highly impressed. If you roll it in your fingers, it feels greasy—that's another sign of the forest's virginity," said Davis, running his thumb over the black soil in his hand.

Strolling along the trail, Davis pointed out some of the larger trees that prove the forest's age. High above the trail, a pair of Cooper's hawks screamed as they circled over their home.

"They're probably nesting above us in one of the taller trees," he said, then sucked in a big lungful of the evergreen-scented air.

"One of the nicest things about it is the smell," he said, then smiled with pleasure.

Davis showed Keener the drainage ditches that he carefully dug to drain the water off the trail to prevent erosion.

"I have tried to dig small, unobtrusive ditches to drain the water off. The trail needs to have some water bars built on it. The science department has proposed that we and the students maintain it to preserve it as a hiking trail," he said, walking up the gentle ascent.

Chimes from the Lees-McRae Tower sounded the hour, silencing the scolding wrens in the forest. On the lower side of the trail, a rhododendron bloomed with its pale pink blossoms. Approximately halfway up the path, a weathered monument dedicated Hemlock Hill to John Marshall Knox, whose gift has saved the ancient trees.

At the uphill end of the trail, Harrison and Edna Baldwin have lived for close to 50 years. Harrison, who worked for Lees-McRae for nearly that many years, remembers when the

*John Keener (left) and Ken Davis (right) pause on the trail beside large hemlocks.*

path was a road, "a nigh cut" from the campus to Hickory Nut Gap Road. Edna finds it to be a wonderful resource today.

"It's supposed to stay a nature trail. I hope it does. It's a peaceful place. It's a place to go when you're in trouble, when you just can't stand it anymore. You sit for awhile, and you feel renewed. A feeling of peace comes on you," she says, recalling times that she has found comfort in the natural beauty of Hemlock Hill.

Living on the mountain, the Baldwins have been visited by bears, deer, rabbits, and other creatures who amble by. They used to have neighbors in small houses nearby, but all have moved on or died, and the old houses slowly subside to ruins as the forest reclaims its own.

In the past, the trail has provided young couples with a secluded place for courting, as well as harried students a place to escape the pressures of tests and assignments.

In the spring of 1999, Lees-McRae President Earl Robinson and Stewart Skeate led the college community across the trail during Mountain Day, a traditional festival when Lees-McRae celebrates its motto, "In the Mountains, Of the Mountains, and For the Mountains."

Hemlock Hill is a piece of the past living into the present. It reminds us of both the grandeur and the intimidating size and strength of the forest our ancestors faced as they entered the mountains.

The virgin forest teaches the mind, soothes the emotions, exercises the body, and inspires the spirit.

"For me, it's the best place on campus, the best thing we have," says Ken Davis, as the hemlocks, maples, and birches murmur in the breeze.

# HIKING MOUNT MITCHELL IN SUMMER

While the valleys in Western North Carolina and East Tennessee swelter through summer heat, the high mountain peaks often provide a much cooler environment. Sometimes it is downright chilly even in July and August, providing perfect conditions for hiking.

When heavy clouds cover the Black Mountain Range and winds blast at 40 to 50 miles-an-hour and more, summer seems as far away as the valley floors to hikers on the 6,000 foot peaks. It is exhilarating, a pleasant, dramatic change from the sultry heat.

Mount Mitchell State Park has always hosted many visitors who climb the tower to see the view from the highest

*The Crest Trail travels over the high peaks from Mt. Mitchell to Celo Knob.*

mountain east of the Mississippi. Increasingly, some of those who make the drive from the lowlands are staying to hike a portion of the trail system maintained in the park.

The trails range from easy, through moderately difficult, to strenuous. With a little preparation and foresight, nearly everyone from the Sunday stroller to the avid trekker can find a hike appropriate for his or her condition and desire.

The Balsam Trail is a 3/4 mile, self-guided nature trail located just below the tower on the top of Mount Mitchell. Rated as "easy" by park officials, the Balsam Trail accommodates young and old alike. Families with small children and elderly grandparents can stay together to enjoy this stroll along the high peak.

A booklet available at the concession stand at the parking lot on Mount Mitchell gives detailed explanations of the Balsam Trail's route. Keyed to numbered posts located beside the trail, the booklet answers many of the questions visitors to the mountain frequently ask, such as "What's killing the trees?"

The trail booklet also explains much about the special environment of this high elevation peak which has "a climate and forest similar to parts of New England and southern Canada." Hikers can learn about the flowers, trees, rocks, ridges, mammals, birds, and insects that make the mountain special.

Human history on Mount Mitchell is also covered. The trail takes visitors past Camp Rock, "used for shelter and camping from about 1850 until after the establishment of the park. It was used so much that at one point it was dubbed the 'Black Mountain Hotel.'" Here, an ancient rock ledge covered with vegetation protects a deep cavity from the weather.

The trail ends at the parking lot just past the old spring where animals, Indians, and early explorers slaked their thirsts on the rocky peak.

A more difficult hike is the Commissary Shelter Trail that begins at the Ranger Station just inside the gate to the state park. A broad trail, formerly a road, runs below the peaks to the site where a small supply store operated from 1912 to 1915.

The difficult part of this trail is the hike back to the starting point. It slopes gently but steadily downhill on the outward leg, but returning, the gentle slope seems to steepen. This trail passes through a variety of grassy bald meadows, heath balds, tumbling mountain streams and woods.

At mid-summer, fields of St. John's Wort, with dancing yellow blossoms, contrast the dark, spruce-fir forests above. A constant hum of bees rises from the flowers, while the buzz of questing hummingbirds cuts the air. Often when the high peaks are deep in thick clouds, this trail allows an open view with the dark ceiling just above.

The most strenuous, as well as the most spectacular, path is the Deep Gap Trail. Starting in the picnic area below the parking lot on Mount Mitchell, this up and down trail follows the crest of the Black Mountains all the way to Celo Knob at the far end of the range, then down to the trail's end on Bolen's Creek outside the city of Burnsville.

"It's one of the most difficult hikes in North Carolina; that's including the whole 12 miles. But it's one of the prettiest trails in the state," says Rusty Bradley, park ranger.

An option to hiking the entire range is to gauge your strength and to turn back when you are about halfway to exhaustion. Many beautiful sites stretch the length of the trail, and by keeping track of where you have been, you know where you must go when you turn around.

"A real popular hike is from the picnic area to Mount Craig, a two mile round trip. Mount Craig is the second highest peak in Eastern America," says Bradley.

The trail winds along the crest through the wind-battered spruce-fir forest. On a clear day, mountain ranges extend to the horizon looking like billows on the ocean. On a cloudy day, gray mist tears by in tatters or thickly envelops you like a gray blanket.

Breaks in the forest open up fields of flowers, grasses, blackberries, and raspberries. In places the gray, rocky bones of the range poke through the thin soil. The dramatic beauty of the peaks alternates with the soft loveliness of thick moss, ferns, and lichens under the spruce-fir forest.

*Logs on Mount Craig keep hikers on the trail to avoid damage to endangered species.*

Rare and endangered species of vegetation and animals live along these trails. Staying on the defined path is important in preserving the environment in which they thrive.

"This is an extremely fragile habitat. Stay on the trail," says Bradley.

Other trails wind around the park. To enjoy a respite from the heat of summer while getting exercise and a breath of beauty, choose one that matches your abilities and give yourself the time to enjoy a leisurely hike along the rooftop of Eastern North America.

Be prepared for dramatic changes in weather.

## CHESTOA VIEW OVERLOOK

Along the Blue Ridge Parkway, many overlooks with spectacular views invite motorists to stop to enjoy the sights; also many trails invite visitors to stretch their legs and travel through the natural beauty of the Southern Appalachians. Some sites have tales to tell about the history, culture or folks of the area.

The Chestoa View Overlook and Loop Trail bring all of these attractions together at one place. The views are wonderful, the trail is relaxing yet invigorating, and a recent mysterious tragedy haunts the scene.

Located at mile 320.8 of the Parkway, Chestoa View draws hundreds of visitors a day. Most of them merely stop to enjoy the view at the first overlook, a rocky balcony hanging to the edge of Humpback Mountain. Atop the precipitous 500-foot drop to the floor of the North Catawba River Valley, the rock-walled crow's nest gives a clear view of the rocky cliffs on Linville Mountain and of a small farm hiding among the trees far below.

*First overlook is a favorite place for sightseers.*

Through a gap in Linville Mountain, the flat top of Table Rock appears even on hazy summer days. Below and to the west of the overlook, the bleaching trunk of a tall, dead tree rises beside a sheer rock cliff, hinting at the dangers below. Recently, just below the rock wall of the overlook, a pair of snakes basked in the sun on a small ledge.

Often you can see hawks and vultures riding the updrafts from the valley, searching the valley floor and the steep walls of the mountains for an unwary squirrel or rotting carcass.

Couples and families find this spot an ideal place to rest, sitting on the walls or steps to look out at the many sights. On a sunny summer's day, Gary Martin and Cindy Pardue arrived on a motorcycle to enjoy the beauty. Using his binoculars, Martin scanned the wall of the mountain facing him, as well as looking into the depths of the valley.

Reynolds Neely and his son Ryan took advantage of the scenery to practice their photography skills. Reynolds was working with his son to help him get his photography merit badge in Boy Scouts. Ryan focused on the tall, dead tree by the rock cliff, listening to advice from his father about framing and exposure.

Billy and Karen Walls had their two boys, Kenneth and Scott, with them. While the boys climbed on the rocks above the overlook, their parents rested on the wall, keeping a sharp eye on their children, for the drop from the ledge is deadly. The Park Service has built a new rail to provide some protection along the rock stairs leading to the platform.

At the top of the steps, a short trail, less than a mile round trip, leads along the ledge of Humpback Mountain. Large oaks tower above the path, providing shade to cool you even on hot days. The well-trodden path is fairly level, so you can move quickly, like the rabbit, which is what Chestoa means in Cherokee.

A breeze fans you as you hike and sets the many wildflowers and vines dancing. At one point on the trail, a maze has formed under tall rhododendron bushes, where you can rest and enjoy the quiet.

False foxglove, black cohosh, greenbriar, false Solomon's

seal, Indian pipes, and wild sunflowers grow below the tall oaks, hemlocks, lindens, hickories, and other trees, and there are huckleberries and blackberries to snack on in season. Mushrooms thrive on mossy logs.

Some poison ivy lurks along the trail, so keep your eye out for the shiny, three-leaved villain.

About halfway along the path, you will come to a split rail fence that signals another excellent viewpoint. From here you can see further down the valley and over to Grandfather Mountain on the horizon.

*The Loop Trail travels through the woods.*

Traveling the ledge, the trail curves back to meet itself to take you back to the parking area, where picnic tables provide an opportunity to recruit your strength after the hike.

Here, the Randolf family from nearby Burnsville enjoyed a good, old-fashioned picnic under the oaks. Entertaining his sister, Bobbie Cox, from Tampa, Florida, Clarence, the father, took his wife Nancy, and their children, Kimberly, Sarah, and Daniel to the overlook, where they enjoyed the view while they developed an appetite. But they were not thrilled with the snakes.

Most of the many folks who visit Chestoa Overlook and Trail are looking only for the view or the exercise, but some make the trip to see the site where two women fell to their deaths in October 1988. Authorities first believed the falls were accidental, but later the husband of one of the women

*Dylan and Mitchell Joslin try to clasp their hands around a large oak tree.*

was arrested under suspicion of murdering his wife and her friend.

James Gibbs claimed that he was taking a picture of his wife, Helen, and her friend Susan Haire as they stood on the wall of the overlook; they both fell to their deaths, Helen Gibbs a distance of 484 feet, and Susan Haire, 189 feet. According to Gibbs, he fell himself while trying to reach the women. He was found by rescuers approximately 20 feet down the mountain.

In June of that year, Gibbs' first trial ended in a mistrial when two of the 12 jurors refused to go along with the other ten in rendering a guilty verdict. A year later he was acquitted of the charges in a trial that ran for four weeks, which included revelations of infidelity, attempted suicides by the two women, and alleged abuse by the defendant.

For some, the deaths are a mystery that will never be explained fully. They come to look over the wall at the vertiginous drop. What actually happened on that crisp October night when the mountains blazed in their autumn finery will never be known.

Humpback Mountain speaks only in the murmur of the wind through the trees and the screech of the hawk above.

# ABANDONED MINES

The history of the Southern Appalachians is found on the face of the land as often as in the pages of books. Abandoned mines leave enduring messages for generations, the open pits or dark shafts speaking of times past.

Many of the old mines from the early part of this century are open scars just beginning to heal in our day. Between Burnsville and Spruce Pine lies Little Celo Mountain with its wounds waiting to be read.

Dennis Silver, a student at Lees-McRae College, grew up under this mountain and has spent his life exploring its coves and crest. Recently he brought a couple of his college classmates to explore the mine sites on his home mountain. He has been intrigued for years by the raw holes.

*Sunlight sparkles in the water-filled pit of the Johnson Cove Mine.*

"The first time I went was in grade school, about fifth grade. I got my motorcycle, and we used to ride up there all the time. My cousin had told me about them. He was always interested because our grandfather worked in the mines," says Silver, as he leads his friends around the edge of the water-filled pit of the Johnson Cove mine.

Feldspar was taken from this pit early in the century. Principally used in manufacturing pottery, this white-to-pale-gray mineral is mined extensively around the Spruce Pine area in the present day. The Johnson Cove mine has not been worked in decades.

Today the mine is backed by a sheer wall cut into the mountain. The pit lies beneath this wall and the opposite wall that is lower. A small stream has cut through the lower wall to drain the overflow water from underground springs and from rain and seepage down the rock face.

A legend about the mine has intrigued Dennis for years. Supposedly a man with a horse and wagon was on top of the high back wall; when something spooked the horse it charged over the side to sink into the dark waters of the pit below. The man's body and the horse and wagon were never recovered.

"My cousin told me that the man had taken the wagon to get firewood from above the mine. The horse spooked or the bank broke off, and he rolled in. That could be a myth, I don't know," he says, as one of his classmates, Brian Rosser, prepares to dive into the pit in a wetsuit with fins and mask to see if he can find any traces.

The first thing Rosser discovers is that the water is cold, much colder than he expected. As he swims out among the swarms of tadpoles, he turns to say that he is freezing and that the pit is more shallow than legend reported.

"The water is cold, in the 40s. The bottom is real soft," he says, as he surfaces to blow water from his snorkel.

As he moves to the middle he finds it to be about ten feet deep. The water is clear, but there is no sign of a horse and wagon.

"There's leaves and rocks and trees and sticks and tadpoles and mosquito larvae, quite a bit of mosquito larvae, but

*Amanda Lineberry and Brian Rosser wait outside Kyanite Mine.*

that's about all. The bottom is real soft, full of sediment and leaves," says Rosser as he emerges from the freezing pit.

Over the decades, whatever was in the mine has been covered by the silt and leaves from the forest. The pit, which had been described as over a hundred feet deep, is now quite shallow.

As Rosser warms himself, Amanda Lineberry records the scene on film. She also takes pictures of the mine wall and the pit. Grooves where miners drilled the rock to insert

dynamite run down the face of the wall.

According to Dennis's Uncle Bill, a man named Boone was killed when loading dynamite into one of the drilled holes. The iron pipe he was using to push the sticks of explosive struck a spark from the rock. The spark ignited the dynamite that blasted him to his death into the pit below.

Less than a mile away is another mine that claimed lives earlier in the century. A large U-shaped pit with steep sides shows where tons of the mineral-rich rock was blasted out of the mountain to obtain kyanite. Nearby, a cave-like shaft remains where more of the material was carved from the solid rock of Little Celo Mountain.

The book *North Carolina: Its Geology and Mineral Resources* by Jasper Leonidas Stuckey, published in 1960, singles out this mine as the primary producer of the mineral used as furnace lining in metallurgical and glass manufacturing furnaces: "The most extensive kyanite mining in North Carolina was carried out in this area near Little Celo Mountain, about two miles southeast of Burnsville. The deposit worked, while somewhat irregular in outline, is about 250 feet wide and 200 feet long.

"It consists of biotite gneiss averaging from about 12 to 20 percent kyanite. It was developed largely by open cut with some attempt at underground mining."

The underground cave holds a foot or two of water now in its large opening chamber. To the left, another room opens in the blackness, and overhead a wide shaft disappears.

"We used to come up here to ice skate in the winter," says Dennis, as he leads the way into the dripping cavern.

His voice echoes hollowly inside as he splashes through the water around the edges. Under the surface, old logs glow an eerie phosphorescent green as ripples spread from the drops falling from above. The cold cave quickly replaces with shivers the sweat raised by nearly 90 degree temperatures outside.

Returning to the sunny heat, Dennis pauses in the cave's mouth before walking to the U-shaped cut about fifty yards away. Steep, smooth walls rise from the boulder-strewn

bowl. The students gape at the precipitous drop.

In the late 1930s, a man named Bennet was killed here. The airhose on the jackhammer he was using to drill with broke loose and blew him off the wall to the pit floor over a hundred feet below.

"Folks say they had time to hear him praying as he fell," says Dennis, who walks alone to the top of the pit. His fellow students prefer viewing the mine from the floor rather than the wall.

A hardwood forest surrounds the mines now, and hunters are just about the only visitors to the once busy place. The students' informal field trip has shown them history writ large in stone. It's a tale they will not have to review to remember.

*Brian Rosser wades into Johnson Cove Mine.*

# WATERFALLS

The wildness of the mountains pours forth in their waterfalls. Power, beauty, and natural music flow over the worn ledges and into deep basins hollowed by untold centuries of gravity-driven water pumped from the hearts of the masses of earth and rock.

Each season of the year creates a different wonder at waterfalls, but the summer has its own particular magic that draws visitors to the thunder of area cataracts. Flowers provide color and delicate scents, while cooling mists spray, providing nature's air-conditioning that proclaims itself with unabashed roars rather than machine whispers.

Swimmers and waders find that the chill of winter remains in the waters of summer. The icy waters dismiss the heat of summer with an ache that lingers as the bathers stretch out on the boulders strewn below the rush of water.

Fishermen find their quarry in the oxygen-charged depths continually stirred by the plunging flow. Trout lurk beneath the white curtains of water in deep holes.

Sight-seers are drawn by the spectacular majesty of waterfalls. Each one has its unique setting and its particular beauty. Tourists attempt to capture on film and tape the visual impact, but find it difficult to carry away the deafening roars, the coolness, and the fresh smell of the falls.

Hikers seek the beauty of falls, enjoying tramping up and down the surrounding ridges and descending into the scooped basins. Trails often wander through the rich forests in their descent to the falls.

We are fortunate in this area to have an abundance of waterfalls near at hand. Several are both stunning in their beauty and easy to visit, with well-developed trails. Elk Falls, Linville Falls, and Crabtree Falls are all located within an easy drive from Mitchell County and are all relatively close together.

Just across the North Carolina-Tennessee state line lies

Elk Falls, just before the town of Elk Park, North Carolina. After crossing the state line from Tennessee, turn left off Highway 19 E across from the Sunrise Market, then take the next left onto state road 1305 that runs beside the river.

The U.S. Forest Service maintains a recreation area at the site. A trail leads to the top of the falls, where the Elk River plunges over a shelf of granite into a deep pool below. Wooden steps will take you down to the large basin.

*Elk Falls*

Linville Falls can be reached by driving back to the Blue Ridge Parkway, then driving south to milepost 316.4 where the Park Service maintains a visitor's center and a network of trails that provides access to the falls in several places.

The Plunge Basin Trail goes to the left around the falls and leads to the Plunge Basin Overlook, a rocky balcony directly overlooking the basin where the waters plunge. A path splits off the main trail to descend to the basin itself where the cold waters of the Linville River crash in clouds of mist.

Crossing the river at the visitor's center and curving around the right side of the falls is the Erwin's View trail, with several overlooks. The first is just above the falls. Here you can look directly over the narrow channel carved through the quartzite where the river corkscrews down to pour over

the final ledge in a massive explosion of water.

Further along this trail are other overlooks high on the steep walls of the gorge. At this season, Catawba rhododendron can be found blooming at various places around the falls, lending their brilliant purple-red blossoms to the perennial beauty of the green hemlocks and gray rock.

Approximately 23 miles farther south on the parkway is Crabtree Meadows

*Rhododendron blossoms frame Linville Falls from overlook on Erwin's View Trail.*

and Falls at milepost 339.5, about eight miles from Gillespie Gap outside Spruce Pine. The Crabtree Falls Trail leads through a deep forest of massive hardwood trees and many varieties of wildflowers. On steep sections of the trail, steps have been built to make the hike safer.

The 90-foot-high fall rushes in a gauzy sheet of white over a narrow ledge to spread a veil over the black rock wall. Mist flows down the gorge above the creek, moistening many flourishing ferns in the dim, green light under the forest canopy.

While the other two falls have an open aspect because of

*Crabtree Falls*

the breadth of their gorges where the waters plummet, Crabtree Falls is enclosed in the forest, giving it a cathedral-like aura that quietens visitors, who sit on mossy rocks to soak in the special atmosphere.

While an ambitious waterfall aficionado could manage to visit all three sites in one day, he would be a tired soul. To properly appreciate the beauty of these places, you should spend time exploring each one, for each has its own particular magic.

There is no better season than summer to make your visits, for the coolness of the falling waters provides a welcome respite from the heat. But be careful, for over the years each falls has claimed victims; slippery rocks, steep drops, and gravity make a deadly combination.

# UPPER CREEK FALLS

On even the hottest days the icy waters of Upper Creek Falls will give you relief. From above the main falls to below the lower falls, you find a wide range of opportunities for the creek to raise goosebumps and give you shivers.

A Pisgah National Forest sign announces the location of Upper Creek Falls on North Carolina Highway 181 between Pineola and Morganton, and at the parking lot two signs point the ways to the Upper Falls and the Lower Falls. Both sites provide thrilling opportunities for cooling off from the summer heat.

Upper Creek Falls is a steep cascade that roars over a rocky ledge to plummet into the narrow, rocky bed that winds down the mountain before eventually joining the Catawba River. Miles of creekbed hold a variety of pools and cascades for sliding, swimming, and enjoying the scenic beauty.

Above the main falls lies the Jonah Hole. Located below the upper cascades and above the main falls, this bottomless pool has a mythic reputation. A few years ago Lindsey Lacey, who

*View from the pool below Upper Creek Falls.*

*Mitchell, Dylan, Blanche, and Pam Joslin slide down the chute at Lower Falls.*

lives in Avery County, tried to plumb the bottom by lowering a 180-foot-long rope with a rock on the end into the hole, but it never touched bottom.

Ralph Beam, a Jonas Ridge native, recalls a story his father told him about the time he caught a brown trout in the Jonah Hole. The fish was so big, its tail dragged the ground as Pap Beam climbed up the trail carrying it over his shoulder.

"When he put it in the dish pan, its head hung out one side and its tail hung out the other, and its middle was bowed down into the bottom," says Ralph, shaking his head in wonder.

Few of the folks who swim in the Hole know how far from bottom they are. A swinging rope hangs from a tree over the deep pool, and a favorite way of entering the icy waters is to swing out and drop into their emerald depths. Everyone has his own way of making the plunge, but each enters the water with a shriek.

Some folks prefer to bathe in the sun, and the many large boulders surrounding the pool make excellent tanning beds. Others like to climb to the top of the cascades or sit on ledges

at the bottom to experience the cooling rush of the waters without immersing themselves entirely in the icy element.

Just above the main falls is a camping spot which usually has a tent or two set up at this time of year. The moving waters sing a soothing song, blossoming rhododendron perfume the air, and the creek provides unlimited recreational opportunities.

One of the favorite activities for visitors is to slide along the natural water chute at the Lower Falls. The creek funnels into a narrow channel that darts down to land in a large, shallow pool. Singly and in trains, folks scream down the chute, bounced from left to right, before hurtling into the pool.

Those who persist in sliding for an hour or more end up with holes in pants seats and sore bottoms, but that doesn't stop their fun. Screams and laughter resound along the creek bed all day long, while the sun shines and the temperature rises.

Recently, Bruce Abernathy brought his family to Upper Creek to show them the good life. A Hickory native, Abernathy now lives in Fort Pierce, Florida, but spends time in the summer at his vacation home on nearby Beech Mountain.

"When I was growing up as a teenager, I found all these places. I'm educating my family on the good things of life. And they are all up here in these mountains, I tell you," he says, as he cleans a rocky firepit to start a campfire for roasting hotdogs and marshmallows to feed the 12 members of his family he has brought to experience "the good life" of Upper Creek Falls.

If the boisterous life is not what you seek, all along the bed of the creek lie beautiful views and restful places to sit and enjoy nature, as well as quiet pools to cool in.

The only requirement for enjoying the wonder of Upper Creek Falls is that you must hike down from the parking lot. While the hike down usually is enjoyable, some folks find the hike back up to be a chore. Just remember, for every foot you climb down into the gorge, you need to climb a foot back out, natural step aerobics that accelerate your pulse.

*Angler tries his luck in the pool above the falls.*

The Upper Falls is not far from the parking lot, but the Lower Falls require stamina to experience. The trails can be slippery when wet, and the rocks of the creek are always hazardous, so watch your step. If you are in a hurry, find another place to spend the day, but if you have the time, there's no better way to enjoy the heat of summer.

# ASHEVILLE BOTANICAL GARDENS

One of the most important resources of our mountains is the tremendous diversity of plant life that is unsurpassed in the world. As a result of the topography of the area, as well as its geological history, plants that flourish in the far South find themselves neighbors of plants that have their primary habitats in central Canada.

Celebrating and providing a haven for this unique resource for all of the people of the Southern Appalachians is the Botanical Gardens of Asheville. Established in 1960, this collection of plants native to the region is a calm and beau-

*Water pours from the large watering can sculpture to splash into pool of sensory garden.*

tiful oasis on the border of the campus of the University of North Carolina at Asheville.

"This place is particularly about the native species of the Southern Appalachians. The plants that we have here are far more diverse than those in Europe. The first French and English explorers looked around and said, 'What a paradise,' and began to collect our plants to send back," says Randy Burroughs, landscape architect who is the manager of the gardens.

The Botanical Gardens are a wonderful example of how a community can create and maintain at bargain rates, a natural preserve that is also a haven for nature lovers and harried citizens. From its inception, no multi-million dollar burdens have been placed on the people of Asheville or the state.

According to the gardens' brochure, their budget comes from memberships, contributions, and memorials. Volunteers perform most of the work, both administrative and hand labor, of the institution.

"It's non-profit. All this was built out of volunteer labor and contributions. We are independent of the university, and we don't receive state funding. I'm part-time, and there is a part-time gardener who lives downstairs. We are the only paid employees," says Burroughs as he works on plantings in front of the Botany Center at the Botanical Gardens.

The former manager, Edward Caldwell, strolls by. He explains that the ten acre site has over 900 species of plants. He laughs before saying, "I still live here and still volunteer in the gardens."

From tall trees hundred of years old to small wildflowers transplanted in the past few weeks, a bounty of vegetation thrives here. The plants that fill the acreage have come from throughout the Southern Appalachians, many of them collected by volunteers.

"A lot of plants come into the garden by volunteers rescuing or gathering them from threatened areas. Some have been taken from highway construction sites. Many of the plants in our rock wall here came from the I-26 construction.

"We got a lot from the Lake Jocassee Gorge in South Carolina before it was flooded. That's where we got our Shortia from," says Burroughs, referring to one of the rarest and most famous plants of the Southern Appalachians that thrives here.

I recently took my family for a visit to the Botanical Gardens, Although we are more accustomed to enjoying nature in its wild state, we found the landscaped plantings to be both informative and pleasant.

*Gazebo in the sunshine meadow provides a pleasant place to relax and enjoy the garden.*

Trails wind throughout the site to take visitors past the myriad of trees, shrubs, and flowers while protecting the vegetation. Natural creeks also flow through the park, adding to the scenic beauty while combating with their cheerful gurgling the road noises from nearby highways.

That babbling sound is one of the attractions of the Sensory Garden, located near the Botany Center at the front of the gardens. Called the "Garden for the Blind" in the past, this special corner is designed to allow those who can't benefit by the visual beauty of the gardens to enjoy other natural sensory stimulation.

At this summer season, we enjoy the blossoming bee balm with a sweet scent from the bright red blossoms wafting in the light breeze. The bright green leaves emit a strong minty

odor when crushed and taste refreshing when sucked. Other flowers bring their distinctive scents as they blossom according to the season. A fat bumblebee hums loudly as he explores the lavender blossoms of some hostas.

In the middle of the Sensory Garden, a rock wall encloses a rectangular pool. In the center of the pool, two sculpted hands hold a large copper watering can with a constant sheet of water flowing from its spout. The restful sound of the splashing water complements the sound of Reed Creek running below.

A bridge crosses the creek to take us to the Sunshine Garden, a large meadow with trees, shrubs, flowers, and rocks. A gazebo here provides a restful spot for sitting to enjoy the peace and beauty. Nearby, a flowering wineberry plant promises to have tasty fruit in the near future. Squirrels and birds enliven the scene with their explorations, chatters, and whistles.

Signs throughout the gardens identify the trees and plants for us. Part of the fun is to see how many we can identify correctly. Various oaks, pines, and maples join yellow poplars, lindens, sycamores, birches, and other trees, while berry bushes, laurel, rhododendron, wild roses, oakleaf hydrangia, and other bushes shade the trout lilies, jack-in-the-pulpits, wake robins, Solomon's seal, larkspur, and other wildflowers.

One sign of the wild aspect of the civilized gardens is a small cottontail we find in the garden path on a rock. The rest of the rabbit is missing. A resident fox must have had a good meal.

A good place to rest is the Hubert Hayes cabin at the far point of the trail. This dogtrot-style log structure came from California Creek in nearby Madison County. Not far from the cabin is Margie's Springhouse, with touch-me-nots and daylilies blossoming around it.

Near the springhouse, we stop to enjoy the ripe, red raspberries bending their canes over with the heavy crop. Further on, Sycamore Meadow holds a large, old sycamore with a bench beneath. Also there is a smaller tree, with a plaque

*Shady path leads through native plants to gurgling creek.*

that reveals that the small sycamore was grown from a seed which traveled to the moon in 1971 on Apollo 14.

Ducks paddle by on the creek behind the tree, and a plumleaf azalea displays its bright red blossoms. From Sycamore Meadow, the trail takes us back to the Botany Center through the Rock Garden, where small rocks and large boulders complement the plants growing among them.

According to Burroughs, he and his volunteers are working on creating a bird garden and a butterfly garden, with plants and trees to attract the flying creatures in large numbers. While he has established plans for the future, the nature of the gardens and its supporters means that surprises will probably happen to enrich the wonderful place.

The Botanical Gardens are located at 151 W. T. Weaver Boulevard. To get there, take the UNC-A exit off Highway 19-23, turn left on Broadway, and then left on Weaver Boulevard, where you will see the entrance sign. For information, call (828) 252-5190.

# HERITAGE ROSES

Clotta Smith celebrates her heritage by surrounding herself with beauty. She collects old varieties of roses to bring into her life today the vivid colors and sweet scents that brightened the lives of her forebears.

"Collects" is the polite word; her husband uses the more descriptive term "rustles." No antique rose in three counties is safe from Clotta's searches and seizures.

"She rustles plants from all over the place. She was a rose rustler before rose-rustling became popular. She's done it all of her adult life, and probably when she was a child," says her husband Eustace Smith, a medical doctor who has served the area for over 40 years.

He smiles affectionately at his wife as she works among her heritage roses that climb walls, crawl up arbors, grow into large bushes, and scale poles and fences at the Smiths' home that tops the hill overlooking the Crossnore area. Despite the occasional embarrassment, he gladly helps her collect the plants that capture the past for her.

*Blossoms from Tuscany (left), Russel's Cottage (center) and Molly.*

"We've been to total strangers' houses and asked for roses, and he just goes along and grins. He's real supportive in it," says Clotta, holding one of her favorites—the Apothecary Rose.

She found this rose at her Grandmother Parker's house and cut shoots to establish it at her home. She loves it for its associations with her grandmother, who was raised near Crossnore, as well as for its intrinsic beauty.

"The Apothecary Rose is my favorite because it was my Granny Parker's. I love her. She's sort of like the rose—quiet and peaceful and a caring type of person. She's the kind of grandmother you dream about.

*Clotta Smith cares for her heritage roses.*

"This rose's face is different from other roses. It opens up. Most roses are all clustered up, but it has a broad face. You can see it from a distance. It's real striking," says Clotta, surrounded by the offspring of that first shoot from her grandmother's homeplace.

Researching the rose to identify it and to learn its history beyond her family's connection with it, she discovered that its story is fascinating in itself. She learned that it was brought back to England from the crusades in the Middle Ages and got its name from its medicinal qualities. Also, it has royal connections.

"It is the rose that was the Lancaster rose during the War

of the Roses in England. It's a red rose, and the York rose is white," she says, as she refers to one of her books on roses.

When she got the Apothecary Rose, Clotta also took some cuttings of the *Belle de Crecy* which was mixed in with it at the Parker homeplace. This rose was named in 1829 for the famous courtesan Madame de Pompadour and was grown at her Chateau Crecy near Paris.

From her Grandmother Oakes, who was brought up near Bakersville, Clotta inherited another favorite, which she has dubbed "Molly." She has been unable to identify it without doubt. The Oakes house stood at Miller's Gap between Crossnore and Newland, and Clotta moved the rose from there years ago.

"I don't know where the rose came from before it was at her house. It must have been there a long time, because she moved there in 1945 and it was there when she got there. First I moved it to my father's years ago. I wrapped it up with string and got it back to my dad's house.

"I was all eat up by the thorns. He asked me, 'What are you going to do with that?' I planted it there, and then later I brought it here," she says, showing the pale rose.

Molly climbs a wall by the front of the house and winds around an arbor lower in the garden. The blossom starts out with a pink hue then gets whiter and whiter.

"It may be the Duchess D'Angouleme or New Dawn, or it may be a sport of one of them. If any of your readers know what it is, they can call me and tell me," she says.

Clotta raids strangers' gardens as well as relatives'. Her bright Harison's Yellow she found at Virgil Murdock's in Mitchell County.

"I was lucky enough to be driving on Bear Creek Road and saw Virgil Murdock had a bunch of roses growing in his yard. I noticed there was a lot of old roses. I asked for a cutting, but he said, 'Honey, we'll dig you some,' It's one of my first roses to bloom," she says, standing beside a chest-high bush with a few yellow blossoms left.

Harison's Yellow is named for attorney George Harison, who raised it in his garden in the early nineteenth century

in New York City.

From the Murdock house, Clotta also got one of her most beautiful specimens, the Tuscany Rose.

"It comes from 1590. Sometimes people call it Old Velvet. It smells wonderful and has a large blossom," she says, pointing to the dark crimson blossoms that exude a deep fragrance.

She has forgotten where she rustled some of her roses. The Russel's Cottage has been part of her garden for so long she can't remember its origin.

*Antique roses climb a Locust post at the Smiths'.*

"I'm not sure where I got that. Probably I was traveling around and saw it and asked for it. It's been here a long time. I think it was first named in 1837," she says, pulling a spray of the bright red blossoms to her nose for a sniff.

The scent is one way that she identifies her antique varieties; however, as she says, "A lot of times the scent doesn't go along with the description. Most antiques have a smell. Some are pine-scented, some are sweet-scented. Most modern hybrids don't smell."

Clotta gathers a blossom from Molly, one from the Tuscany, and one from another heritage rose, *Reine Des Violettes* and compares their fragrances, each of which is quite distinctive.

"Some of my friends make potpourri out of them, but I can't stand to cut them and bring them into the house. I just

let them do their own thing. When the wind blows right, it brings the scent right up to the house," she says, looking down over her blossoming estate.

Several other antiques haven't bloomed yet. Her Seven Sisters still bears the hips from last year's blossoms.

"It's called Seven Sisters because there is usually seven in a cluster. It goes back to 1815," says Clotta, standing near the rail fence that the rose climbs.

Her large bush of Rambling Rose is also about to blossom and join the natural celebration of heritage on the Smith's estate. Clotta's Appalachian roots extend seven generations on one side and six on the other. And as she says, some of her relatives were here to greet the other, since she has Cherokee blood.

The red flowers and the red blood seem to run together.

"I like the heritage, the history of the roses. I like genealogy. Just like tracing my family history, I like tracing the rose's history," she says.

If you have any old roses, be on the lookout for the marauding Smiths on their way to rustle some more heritage. They are determined, so you might as well simply surrender a few cuttings.

## BLUEBERRIES

From early July, signs start popping out everywhere—it's blueberry season. On fruit farms throughout Western North Carolina, bushes are loaded with plump, ripe fruit ready for the picking.

The mid-to-late summer harvest has been a mountain tradition for thousands of years. Before humans arrived to garner a share, bears and other beasts helped themselves without restraint to the small but tasty fruit.

Indians and settlers found the naturally occurring summer bounty a welcome addition to their larders. Filling poplar bark buckets with hand-picked huckleberries was a family affair. Young and old alike could share the excursion to the berry patches.

But gathering the wild berries was a difficult task. Berry bushes were most often located on rocky crests, and it took hours of picking the small wild fruit to fill the buckets.

Today we no longer need to tramp to high mountain ridges to get the native berries. Many mountain farmers have extensive plantings of cultivated bushes that abundantly bear fruit much larger than the native varieties.

Roadside signs point the way to good picking and eating.

*Plump ripe blueberries.*

At Jay Eaton's High Valley Farms, the bushes are loaded. The season is a good one for him and his wife, Maybelle, as I discovered when I took my family to his farm for an evening's picking of his Jersey, Burbank, Blue Ray, and Herbert blueberries.

"It started out poorly because it was dry early on, but then it started raining, and the fruit that we had got quite large," said Jay, as Maybelle handed out the picking buckets.

*Pam helps Mitchell fill his blueberry bucket.*

"Take your people farther out. These bushes here have been picked over," said Jay, pointing to the rows nearest the parking area

The late afternoon sun beamed down into the long rows of blueberry bushes that stretched up into the cove. To the east, Roan Mountain towered, closing the horizon, billowing clouds piling up against its bulk.

My daughter, Blanche, went right to work, filling her bucket with handful after handful of the plump, ripe berries. Even at ten years of age, several years of berrying experience allowed her to move quickly and expertly from bush to bush. Occasionally she sampled a particularly plump specimen, but diligently kept to her task.

"This is the first year I've put more in my bucket than in my mouth," she said as she trickled a palm-load into the white container. "Before, it was one for me, one for the bucket."

Mitchell, at six years old, needed some help with his picking. My wife, Pam, stayed with him, reminding him that the mouth of the bucket needed to be fed more than his own blue-stained mouth. Also, the sight of laden bushes always called him away from the one he was at, sort of "the bushes are always bluer on the other side of the row" phenomenon.

Sharing the blueberry patch on this sunny afternoon were a number of birds. Robins twittered shyly as they kept as far as possible from Dylan, who at eight years old was more interested in sneaking up on them than picking berries.

Bluejays screeched around, diving into the rows, chasing other birds, and generally having a bedeviling good time. Crows cawed from the surrounding trees, waiting for the pickers to move on. Doves mournfully called in the afternoon heat.

I wondered how many buckets of blueberries disappeared each day into beaks. A line from a song popped into my head, "It's summertime, and the living is easy." I asked Jay about the winged thieves.

"I figure they have to live, too. I've heard of people trying to scare them off, but I think that the reality is that the birds mostly pick off the ground. The berries on the ground always disappear," said Jay Eaton, pulling down his white cap. His white beard parted in a smile.

I didn't have the heart to tell him that I watched one robin (Is that where they got their name?) work his way around the top of a particularly rich bush. Maybe that bird was an anomaly.

As buckets filled, arms

*Blanche samples a plump blueberry as she picks.*

became weary. We worked together to finish them off, then took them to Maybelle to pay our $4.00 a gallon.

Jim Parker from Jonesborough was there. He paid $6.00 for a gallon of already picked berries. He had to get back across the mountain.

"We had hoped to emphasize you-pick, but a lot of people won't go to the trouble," said Jay, shrugging the galluses of his overalls.

So Maybelle picks berries each morning, putting the bags into a cooler to await buyers. Their sign on Highway 226 in Buladean directs berry seekers right to their stand and bushes. They're open Monday through Saturday during the summer berry season from 7 a.m. to 7 p.m., and on Sunday from 1 p.m. to 7 p.m.

Down the road, another sign points up Blevins Branch to Arnold Odom's blueberry patch. The Odoms, too, have both pick-your-own berries and prepicked ones for $4.50 and $6.50 for five quarts.

"We're just at our peak. Come Monday through Friday from dawn to dark. On Saturday we close at 5:00, and we don't sell on Sunday," said Betty Jean Odom.

On Hughes Gap Road, handlettered signs point up Odoms Chapel Road to the Hughes blueberry patch, where bushes are loaded and picking is the same price as at Eaton's farm. Outside Spruce Pine in the Grassy Creek Community on Highway 226, a sign directs you to Kay Abernathy's berry farm.

Similar signs throughout the mountains direct berry lovers to the blueberry bonanzas. You usually don't have to walk far at all, and you won't run into a single bear.

# GRAY'S LILY

As early summer establishes itself on the verdant balds, among the wind-rippled green and gold grasses can be seen glowing bits of flame—the blossoms of the Gray's Lily or Roan Lily. This fiery flower with its combination of beauty and rarity has become an important part of the heritage of the Roan Highlands.

Gray's Lily links today to the distant past. It is a rare plant that exists naturally in only a few areas. The Roan is its primary habitat. The lily was discovered there, and the main population of this nationally significant plant exists there today. As the balds go, so goes the lily.

Keeping the balds clear of woody vegetation is a major problem today. This distinctive flower's reaction to vegetation management plans on the balds clearly indicate how successful were the means used to preserve the unique character of the grassy balds.

In prehistoric times, large herbivores kept the balds clear of woody species that eventually would have turned these high elevation meadows into forest. According to the research of Peter Weigl, a biology professor at Wake Forest University, mammoths and mastodons, as well as ground sloths, horses, peccaries, caribou, moose, muskoxen, and

*Asa Gray, for whom the lily was named, probably first noticed it in 1841.*

*A Gray's Lily rises through the ferns near Engine Gap of the Highlands of Roan.*

bison, "ranged the Southern Appalachians."

"The impact of these species, individually and collectively, on the regional vegetation was very likely quite spectacular," wrote Weigl in his proposal, "Southern Appalachian Grassy Balds: Rethinking Both Origins and Management."

Over the millennia, grazing animals kept the balds open. The Indians hunted the herds, and later the white settlers would drive their own livestock to fatten in the summer on the luxuriant grasses.

In late June and early July of 1841, the pioneering American botanist Asa Gray traveled through parts of the Southern Appalachians to study and collect plant specimens. While dazzled by the incredible wealth and diversity of plants in the region, he was equally impressed by the scenic beauty of the open meadows and the mountains on all sides.

He ascended the Roan after climbing Grandfather Mountain.

"It was just sunset when we reached the bald and grassy summit of this noble mountain, and after enjoying for a moment the magnificent view it affords, had barely time to

prepare our encampment," he wrote in an article published shortly after his trip to our mountains.

One of the plants he identified on this trip was the *Lilium Canadense*. According to Jim Massey, director of the herbarium at UNC-Chapel Hill, this species of lily closely resembles the Gray's lily. Gray may have discovered the plant that bears his name on this first visit, but he failed to distinguish it from its near relative.

In 1879, his protege, Sereno Watson, officially described the flower and named it for his mentor.

During the nineteenth century and much of the twentieth, livestock kept the balds open on the Roan Highlands and thus kept the Gray's lily in a flourishing state. Cleo Edwards grew up on a farm below the balds and spent much of his recreation time among the herds on the meadows. He knew the lilies and saw them in the 1930s, 40s, and 50s.

"Yes, they was plenty of them. It seems like they done a lot better then than they do now. The stock kept everything picked down around them," said Cleo, remembering when the balds hosted herds of cattle, sheep, and horses, rather than flocks of tourists.

After the U.S. Forest Service acquired the balds during the

*Gray's lily blossom.*

middle decades of this century, the government stopped the grazing. Shortly thereafter the slow but steady process of woodland encroachment began. As the blackberry briars and alders flourished, the Gray's lilies declined.

In the past two decades, the Forest Service has tried many different ways to prevent the disappearance of the unique habitat of the balds. Fire, chemicals, weed mowers, and other means have been employed with little permanent success.

Then for three years, a herd of goats was given part of the job.

"We have found that where we had grazed with goats, the following year we found hundreds of Gray's lily seedlings where they had not been before," said Frank Roth, a ranger for the Toecane District of the Pisgah National Forest that oversees the balds.

"When we kept the goats out of that place the next year, the blackberries came back and shaded the lilies out. Where we let the goats graze, there were still hundreds of them. We're putting in plots and doing more monitoring of what's happening there now," said Roth.

The goats are gone this year; last summer was the third of a three year test program. Time will tell how quickly the briars and other woody species overshadow the lilies.

The Gray's lily has survived for thousands of years because of the natural process of animal and habitat interaction. Man has disturbed this balance and finds it difficult to reestablish. The beautiful blossoms nodding in the breeze seem to chide our carelessness and to laugh at our shortsightedness.

# WILDLIFE ENCOUNTERS

One of the wonderful aspects of living in the Southern Appalachians is the sense of nature that surrounds us. The beauty of the forest that clothes the ancient mountains is a constant presence, and throughout the year the denizens of that forest reveal the wildness that thrives there.

Sighting a deer or raccoon or bear or bobcat brings an encouraging thrill to a daily drive or a walk in the woods or along a pasture. The sounds of owls hooting or screeching in the night, or doves mournfully cooing in the day reminds us of our wild neighbors and distracts us from our everyday cares. And the shrill cry of an eagle or hawk tells us of a power not our own.

The summer of 1998 was full of such encounters for me and my family. Our farm and woods we share with many wild neighbors. Some of them come closer than they intend, creating problems for them and us.

Early that summer I came upon a pair of fawns, newly born near the edge of my pasture. One wobbled on his

*Wildlife officer Tim Holtzclaw watches the small buck in the pasture.*

*The injured great horned owl was later rehabilitated.*

spindly legs, the other lay still wet from afterbirth and curled on the ground. I heard a doe snorting, and quickly retreated from the woods.

A week or so later my two boys and I came upon a small fawn curled up under a log on a nearby ridgetop. When one of my sons tripped, the small spotted creature jumped up, bleated, and ran about 20 feet to hide in a bush. We then left the ridge.

About a month later a fawn, lost, strayed, or abandoned, found his way to our front yard, literally. Shortly after sunrise I heard a bleating sound in the pasture across the creek from our house. At first I thought someone had lost a goat that had wandered up the creek looking for a home. But when I scanned the pasture, I saw a spotted fawn walking back and forth as he worked his way down the steep slope from the woods.

I looked up at the forest, hoping to see a doe who would rescue him, but none appeared. The cattle in the field looked curiously at the noisy deer, but went right back to their grazing. After several minutes, I lost sight of the fawn but heard its bleating continue.

Then the bleating changed to a shrill squeal. The noise came from my neighbor's barn. I decided to see what had happened. The barn had been closed off to keep the cattle from entering it, but somehow the fawn had worked its way under the barriers. Inside, it had trapped itself between two four by fours that formed a platform. It was unhappy.

I released it from its trap, then put it over the barrier into the pasture again. It walked towards the creek, bleating still. I crossed the water to go back to my yard to see what would happen. Within ten minutes, he walked up my driveway and approached the house. I dragged my curious hound into the house before going up to the deer for a closer look.

My wife, Pam, and I examined it for injuries, finding only a couple of small puncture wounds at the base of its left ear. It was quite comfortable with our presence, rubbing against us and following us around the yard, still bleating.

At this point we decided to get some professional advice. We called the North Carolina Wildlife Resources Commission, getting a message machine because it was too early; Grandfather Mountain's habitat naturalist, who said that they were full up with fawns, and the Western North Carolina Nature Center's rehabilitation supervisor, who said he would take him into their program if we wanted that.

*The young buck shows no fear of our dog, Tackles.*

What we wanted was to have the deer find its home back in the woods in our valley, so we decided to put him in our pasture to see what would happen. He walked back down into our yard and established himself among the clothes drying on our clothesline. He was still bleating.

Soon we got a return call from the Wildlife Commission. The officer said that he would contact our local enforcement officer and have him get in touch with us. Within an hour after a phone call in which we explained the situation, Officer Tim Holtzclaw drove up to our home.

By this time I had taken the fawn back up into the pasture, where it was grazing and bleating. Holtzclaw and I walked up to watch the small buck. The officer was surprised that it was so tame. After I explained the whole morning's activities, he came to the conclusion that someone had been keeping it and had released it or perhaps dropped it off.

"I'm about 95 percent sure that's what happened. It's rare for a deer of that size to be that mild-natured around humans, and to go to a barn is unusual. To go to a barn like

that means it knows what's in there," he said, watching the spotted creature.

He then explained that many people make the mistake of taking a fawn that they find in the woods or pasture, thinking that it is lost. They don't realize that the mother has left it to sleep while she grazes.

"Just leave it alone; don't bother it. They think it's abandoned and bring it home. They are good-intentioned, but it's a mistake. If you can take it back there in six to eight hours, the mother is probably still there. If it's anything more than 24 hours, then it's usually a lost cause," he said as he looked over the fawn for injuries.

Holtzclaw stayed for a couple of hours as the fawn browsed through the pasture, but stayed around. When my dog got out of the house, it ran to check the bleating beast, sniffed at it, and looked puzzled. The fawn rubbed it with his nose, making us think that it had met dogs before. We decided to let it alone for awhile.

Holtzclaw explained that while the Wildlife Commission has a rehabilitation center, the cost is high for each animal and the success rate is only about 50 percent.

"We always like to try this first, especially in a situation like this when it's at the point he can browse and be able to make it. I'd keep an eye on it. He may hang around a day or so, but he's an animal—totally unpredictable."

"We'll let it do its own thing. It might make contact with its mother or another doe. A strange doe won't suckle it, but it will allow it to hang around," said Holtzclaw, who drove off, leaving his number to call if things didn't work out.

After another hour, I carried the fawn up to a spring on the edge of the woods where I had frequently seen does. He drank deeply, then browsed around, bleating. I went back to the house, taking my reluctant dog, who wanted to stay to play with his new friend.

Two hours later I walked back up. A large doe bounded away as I approached the spring. There was no bleating and no sign of the small buck. I breathed a sigh of relief and sent a blessing after him.

# CRAGGY GARDENS

For more years than folks can remember, Craggy Gardens has lured those who love the beauty of nature to its rugged ramparts in the summer season. From mid-June to early July, the slopes and bald peaks glow with the distinctive reddish-purple blooms of the Catawba rhododendron.

With the Blue Ridge Parkway providing easy access and an information center giving directions and answering questions, today you will have a much easier time enjoying these wonders than explorers of the past. In the nineteenth century, the trek by horseback or by foot required hours, yet the storied beauty drew hardy visitors even then.

In addition to those who climbed the mountain for pleasure, farmers living in the valleys under the Craggies would drive their stock to the balds to fatten them during the summer. An old photograph on an information sign in the gardens shows a herd of sheep tended by a roughly dressed keeper on the bald of Craggy Flats, with Craggy Pinnacle, elevation 5,892 feet, and Craggy Dome, elevation 6,085 feet,

*The Visitor's Center and parking area seen from Craggy Pinnacle.*

towering in the background.

The Craggies support heath balds and grassy balds intermixed. The heath balds grow rhododendron, blueberries, flame azalea, and mountain laurel. The grassy balds are covered by succulent grasses and wildflowers.

On Craggy Flats, the two types intermix with the grassy portions forming open areas among the heath bushes. Traces can still be found of barbed wire fences on this mountain, a rounded, 5,526-foot bald on the Craggy Gardens Trail.

A favorite feature of Craggy Gardens is the trail system that allows visitors to explore with safety for themselves and for the delicate environment of the mountains that make up the Great Craggy Mountains. The astonishing variety of vegetation in the Craggies creates a unique system that deserves preservation, while at the same time attracting crowds of nature lovers.

"The Great Craggy Mountains nurture a complex spectrum of forests, heath balds, and grassy balds, one of the greatest diversities of plant communities in the Southern Appalachians. Many regard this as the most important botanical area of the Blue Ridge Parkway. . . . As many as 20 of the plant species of the Craggies are endangered, threatened, or rare," says a plaque in the information center.

The carefully maintained trails provide access to this unique natural community, while steering hikers away from the sites where they might trample upon rare plants. From the Visitor's Center parking area, the Craggy Gardens Trail begins as a self-guided tour through the twisted, high elevation forest to Craggy Flats.

Plaques along the trail teach visitors about the area they are traversing:

"As you travel increasingly higher in the Craggies, rainfall is more frequent and the weather usually becomes cooler and windier. As a result, the character of the forest changes from broad-leaved hardwoods in the warmer lowlands to evergreen spruce and fir on the highest ridges. Forming a thin belt just below the spruce and fir is a northern hardwood forest of

birch, beech, and buckeye. Punctuating this forest are the treeless heath balds," one says.

Along the trail, hikers come across birch trees twisted into fantastic shapes by the harsh, windy environment. At this season, the many Catawba rhododendron bushes form a tunnel embellished by the striking blossoms that hikers admire as they travel the teaching trail. You can learn interesting facts as you stroll the gently rising pathway.

*The Rhododendron form tunnels on trails.*

"The yellow spots on the upper petal of each blossom mark the path to stored nectar and are called nectar guides. Directed by these targets, insects locate food and 'accidentally' pick up pollen grains in one flower and deposit them in another," one sign about the Catawba Rhododendron explains.

Others tell about the denizens of the balds, such as the junco, about blueberries, and about why the rhododendron thickets are call "hells." On Craggy Flats, a shelter constructed from native chestnut logs by the Civilian Conservation Corps in 1935 provides a resting place, and a side trail leads from the sturdy structure to a rocky overlook where you can see surrounding mountain ranges, the piedmont, and the town of Montreat far below.

The trail then gives you a tour through a mixed hardwood forest, ending at the picnic area, which can be reached from the parkway, just south of the Visitor's Center.

Just north of the tunnel that leads to the central parking area at the center is the Craggy Dome Parking Overlook, where the Craggy Pinnacle Trail begins. Although this is a moderately challenging hike, you will be rewarded at the Pinnacle with a 360-degree vista. While many wildflowers greet you on the hike up, several areas are protected by signs, posted to discourage wandering from the way and trampling rare and endangered species of plants.

On the Pinnacle, a sign explains that some of the plants are relics from the last glacial period. It further says, "More than a third of prescription medicines are derived from plant compounds. Extinction of any plant destroys unique genetic structures and robs us of potential medical advances. Losing individual species also diminishes the variety of life on earth."

A trip to the Great Craggy Mountains is rewarding at any time of year, but during the blossoming of the rhododendron, this area is especially magical. You will be reminded of the priceless gift that our mountains are and of our obligation to preserve them.

## THE BLACK BROTHERS

Two brother peaks on the Black Mountain range commemorate two men whose lives intertwined with the crests and hollows of this highest mountain range east of the Mississippi. The two men lived vastly different lives and came from quite different backgrounds, but they are here brought together till the end of time.

For generations, these twin peaks were known as the Black Brothers, "black" for the thick stands of red spruce and Fraser fir that clothed their slopes in dark fir and "brothers" because they stood together on the crest. Today these two peaks which mark the northern border of Mount Mitchell State Park are known as Mount Craig and Big Tom.

*The view of Mount Craig and Big Tom from Mount Mitchell parking area.*

Locke Craig was the governor of North Carolina from 1913 to 1917. During that time, he pushed through the legislation to save this part of the Black Mountains from the blades of the lumber industry that were slicing through the heavy stands of timber on the Blacks.

Big Tom Wilson was a simple woodsman and mountain patriarch who grew to dominate the closed-in valley of the headwaters of the Cane River under the Blacks. A well-known bear hunter, he became famous for finding the body of Elisha Mitchell when the scientist died in his attempts to verify his claims to have climbed and measured the Black Dome, later named Mount Mitchell.

In the summer of 1857, Big Tom was part of the massive search party that sought traces of Professor Mitchell when he disappeared in the Black Mountains. After several days of fruitless searching by hundreds of men, Big Tom's unerring woodcraft discovered the first trace of Mitchell.

In a pamphlet, *Mitchell's Peak and Dr. Mitchell,* issued by Locke Craig in 1915, former North Carolina governor Zeb Vance recounts Wilson's discovery of the marks of the tacks in Mitchell's shoes. These faint signs set the woodsman on the trail that led to the waterfall over which the scientist had fallen to his death.

This discovery of the body began Big Tom's mythic reputation. When the following winter an article in *Harper's New Monthly Magazine* by David Hunter Strother featured Tom Wilson as the guide who led the travel writer-illustrator and his party to Mount Mitchell, Big Tom's fame was assured.

In 1885, novelist Charles Dudley Warner traveled to the Black Mountains. "Big Tom himself weighed in the scale more than Mt. Mitchell, and not to see him was to miss one of the most characteristic productions of the country, the typical backwoodsman, hunter, guide," wrote Warner.

While Locke Craig had also spent much time wandering the Black Mountains as a young man, unlike Wilson's, his career was one of power and politics. Their similarity came in their love for the mountains and their respect for the man who had given his life studying them.

Craig made many treks along the ridges and through the forests of the Black Mountains. As he wrote in 1915:

"Until recently, the only way to the top of this mountain was by steep and difficult trails. But the traveler was compensated for the effort of the journey. He traveled ten miles through primeval forests, and, on the summit, was in the midst of a vast and unbroken wilderness of hundreds of thousands of acres where the axe had never been laid to a tree, except by hunter and trapper."

But when logging began in earnest, bringing a railroad to haul the timber out of these mountains, he found that his beloved forests had suffered tremendous damage. He addressed the North Carolina Forestry Association in January 1915 in these words:

"Last year I was invited up to celebrate the opening of the twenty mile logging railroad from Black Mountain station to Mount Mitchell as a great enterprise. But when I looked all around, where I had been bear hunting as a boy, and saw this vast desolation all below, I told them they had gotten the wrong man to come up and celebrate the opening of their railroad.

"I felt like a man that stood amidst the ruins of his home after the conflagration had destroyed it."

Being a conservative politician, the governor agreed that the loggers could legally take every stick of timber, but he believed that this was one case where the people should exert their political rights to secure the beauty and grandeur from destruction.

"It was on a place like this that Moses communed with God, Who revealed Himself to man. He has given this sacred place to us, and we should do our best to preserve it. North Carolina should protect it, and own it for herself and her citizens forever," he said in his address.

Craig used his political clout to marshal support for a proposal to acquire a tract of the crest to protect Mount Mitchell and some adjacent peaks. Yancey County's G.P. Deyton introduced the bill in the North Carolina House of Representatives and Buncombe's Zebulon Weaver introduced it

*Bear paw print on trail between Mount Craig and Big Tom.*

into the state Senate.

With a preamble that stated, "the headwaters of many of the important streams of the State are at or near the said summit and the forest is being cleared which tends to damage and injure streams," as well as covering the aesthetic reasons for the protection, the bill passed both houses and was ratified into law on March 3, 1915.

Governor Craig appointed five commissioners to negotiate for the land and timber rights with Pearley and Crockett, who were logging the area. G.P. Deyton of Green Mountain, E.F. Watson and M.C. Honeycutt of Burnsville, Wilson Hensley of Bald Creek, and T. Edgar Blackstock of Asheville were successful in their task.

Big Tom (6,558 feet) stands at the far end of the park to commemorate that sturdy woodsman. Next to him towers Mount Craig (6,645), the second highest peak east of the Mississippi, to recognize the role of that canny politician. They are brothers in spirit as well as rock.

The best way to experience the beauty and history of the former Black Brothers is to hike to Mount Craig and Big Tom

along the Deep Gap Trail that starts at the lower parking lot on Mount Mitchell. While the Deep Gap Trail runs for miles along the crest of the Black Mountains, the trip to Mount Craig and then to Big Tom is only about a mile and a half. The trail winds through dark sections of the red spruce and Fraser fir forest, as well as cutting across the bare rocks of the bones of the ancient mountain chain.

With the rise and fall from peaks to saddles, the hike is challenging in places, but short enough for most folks to enjoy. The view from Mount Craig, as well as from rock outcroppings along the way, is spectacular and well rewards the effort to get there. The peak of Mount Craig holds a few stunted, wind-blown trees and bushes along with some species that are on the National Endangered Species List. Park personnel have utilized heavy logs to encourage hikers to stay on the trail that crosses this scenic site.

"We're trying to protect three species on Mount Craig. There is the geum radiatum and a lichen that is very rare. This is one of only two locations that they know of where it survives," says John Sharpe, superintendent of Mount Mitchell State Park.

According to Sharpe, helicopters carried the heavy logs to the summit for workers to place them to route hikers off the rock ledges that are home to the rare species.

"It seems to work. I think it's really going to help. Hikers didn't know before where the trail actually was. The log border delineates the trail and keeps people on it," says Sharpe.

A heavy bronze plaque bolted to a boulder on Mount Craig recognizes the former governor's efforts which led to the establishment of Mount Mitchell State Park. Someone has stolen the plaque from Big Tom, leaving a bare patch on the large boulder sheltered by the spruce-fir forest on the peak that celebrates the exploits of its namesake.

In recent years, bear tracks mingled with the human bootprints in muddy places on the short section of trail between the two peaks. Both Locke Craig and Big Tom Wilson would be pleased.

## CHIMNEY ROCK

Chimney Rock draws the eyes of all who pass in its shadow. The stark monolith crowned by the fluttering red, white, and blue of the American flag stands like a huge mountain pulpit overlooking its valley.

For centuries, this upthrust column of igneous rock has been a source of wonder, as well as a landmark to travelers through the steep Hickory Nut Gorge. Today, Chimney Rock and its nearby counterpart, the steeply falling Hickory Nut Falls, are the main attractions of the privately owned Chimney Rock Park.

Five hundred thirty-five million years ago the molten rock welled up from the earth's deep interior. Originally, an outer crust of earth covered the rock as it cooled, but in the intervening millenia, the work of wind, water, and weather have bared these spectacular shapes to the sun.

The Chimney itself has been formed by the gradual disintegration of the rocks between it and the face of the mountain. It now stands in picturesque isolation.

Over the years, many attempted the dangerous climb to the Chimney's top,

*Chimney Rock from below.*

*The fence provides protection at Groundhog Slide where* The Last of the Mohicans *chase scene was filmed.*

although most travelers simply wondered at it as they passed. In 1870, Jerome Freeman purchased the area. He envisioned a road and stairway to make the trip much safer for those who came to his attraction, which he opened to the public in 1885.

Freeman sold Chimney Rock with 64 acres of the mountain to Lucius B. Morse in 1902, and Morse began the development of the attraction that has led to the easy access the park now provides.

Today you can ascend to Chimney Rock under your own power along a series of stairs or in an elevator that rises up 258 feet deep in the rock. Opened to the public in 1949, this elevator shaft and the 198-foot tunnel to it required eight tons of dynamite and a year and a half to excavate.

The elevator drops you on the main mountain; to get to the Chimney you must cross a gap bridged by sturdy stairs, whose rails support many white knuckles of vertigo-fearing tourists each day.

*The Devil's Head.*

From its top, you can see for many miles into the piedmont on a clear day. Your eyes are drawn down the gorge, to the blue waters of Lake Lure, then to the blue mists over the Carolina foothills.

Strong iron fences provide a sense of security for most visitors, but there are those who hold back from the edge and its sheer drop.

Small potholes in the hard rock of the top of the Chimney tell the tale of erosion. Water that seeps into the rock fissures freezes, then thaws, then freezes again, breaking loose tiny rock particles. The strong winds that play across the top of the Chimney whirl these broken bits around and around to create the circular potholes.

From the Chimney, the Skyline Trail leads over the steep sides of the mountain to the 404-foot drop of Hickory Nut Falls. Along the way, you will see the famous Devil's Head, a nature-sculpted rock perched precariously over a sheer cliff.

Other natural attractions occur along the trail that rises 200 feet to take you to the top of the falls. In the heat of the summer, the climb makes the cold waters that greet you there quite welcome. Most visitors remove their shoes to wade through the refreshing pool made by the waters of Fall Creek as it pauses before its dizzying plunge over the cliff.

At the top of Hickory Nut Falls, no-nonsense signs warn of the dangers. As you look around, the scene may seem

vaguely familiar if you have seen the recent film, *The Last of the Mohicans*. It was here that the climactic fight between Chingachgook and Magua took place.

Many other scenes of the movie were filmed here at Chimney Rock Park, and scores of tourists are drawn here because of the film. The Cliff Trail that descends from the falls to the parking lot has many points that were settings of the dramatic chases and fights, as well as one of the romantic interludes.

Up "Groundhog Slide" came Hawkeye, Uncas, and Chingachgook as they pursued the Hurons. Under "Nature's Showerbath" Magua fought Uncas, and at "Inspiration Point" Cora and Hawkeye embraced.

Added to the interest aroused by the motion picture settings is the beauty of this trail that winds along a narrow ledge at the base of steep rock walls. "Inspiration Point" provides both a view of Lake Lure and the land to the east and a full, clear sight of the entire drop of Hickory Nut Falls.

A few tight squeezes, such as "Wild Cat Trap" and "The Subway," require flexibility and care, but sturdy fences that were removed for filming the movie will keep you safe as you make your way down to the base of the Chimney.

Further down the three mile road that runs from the front gate to the top parking lot, The Forest Stroll Trail leads to the base of the falls. In addition, there is a nature center with displays of the flora and fauna of the mountain, as well as the story of its development.

Chimney Rock Park is open every day of the year except Christmas Day and New Year's Day from 8:30 a.m. to 4:30 p.m. (5:30 p.m. during daylight savings time). It is 25 miles southeast of Asheville, near the intersection of U.S. 64 and 74.

# SASSAFRAS

One of the first products of the newly discovered Americas to seize the imagination of European entrepreneurs and consumers was sassafras. For most of the four centuries since its discovery, this native tree has been an important part of the life of Americas, as well as an important item of trade.

Well before the advent of the white explorers, the native American Indians used sassafras for a variety of purposes, both medicinally and as beverage and food. The Onondaga, the Iroquois, the Seneca, the Meswaki, and the Cherokee, among other tribes, valued the roots, stem, leaves, and branches and employed the different parts in different ways.

According to some authorities, the delightful odor of the sassafras tree was one of the first signs of land during Columbus's first voyage to the New World. In his journal the great discoverer wrote of "breezes as sweet as Seville in April, so fragrant that it is a joy to smell them," two days before sighting land.

This hopeful sign helped to calm his mutinous crew, giving the ships time to reach the first landfall. By 1574, Nicholas Monardes, in his book *Joyful News out of the New Found World*, wrote that the Spaniards, "did begin to cure themselves with the water of this tree (sassafras) and it did them great effects, that

*Pam washes the sassafras root.*

it is almost incredible."

In 1586, Sir Francis Drake returned from America with a load of sassafras roots. The tea made from these roots became a society favorite known as saloop. The demand for the product made sassafras one of the first major exports from the colonies.

The famous Captain John Smith of Virginia reported on the presence of the tree in that colony, and the ships that brought supplies from England would return from the New World loaded with sassafras roots.

In North Carolina, the early explorer John Lawson, who first reported on the Appalachian Mountains, wrote in his *A New Voyage to Carolina* in 1709, "Sassafras was a straight, neat, little tree . . . treasured by the Indians for its aromatic roots, from which, when pounded, a potion can be brewed to refresh or cure, according to one's needs."

In the early decades of the nineteenth century, the essayist Charles Lamb wrote of the popularity of sassafras in England. "This a wood boiled down to a kind of tea, and tempered with an infusion of milk and sugar, hath to some tastes a delicacy beyond the China luxury. . . . This is saloop—the precocious herb-woman's darling."

In the middle of that same century, Francois Andre Michaux, who is known as one of the most important of the early scientific visitors to the Southern Appalachians, wrote a lengthy description of the medicinal uses of the tree. He also commented on the importing and planting of the sassafras tree in Europe.

Throughout the mountains, sassafras tea has been used as a refreshing hot drink throughout the winter and as a valuable spring tonic for as far back as anyone can remember. Old timers recall the large pot that would sit on the wood cookstoves, steam rising from the deep red liquid.

"We always had a pot on the back of the stove. Everyone drank it, as I remember. You don't see it that much anymore," says Garrett Hopson, who grew up in the Buladean community of Mitchell County during the first decades of this century.

*Mitchell digs sassafras roots.*

Another Buladean resident in his mid-eighties, Frank Whitson, remembers the steaming pot of sassafras tea also. He headed a logging business that took him throughout the mountains of Western North Carolina, East Tennessee, and Southwest Virginia, and the men would keep the tea boiling on the Home Comfort stove they kept in the logging camps.

He frequently saw the signs of root collecting in the woods.

"Many times I'd be in the woods looking at a boundary of timber and find a large sassafras tree (he holds his hands two feet apart) with the earth all dug away from the roots and

the bark skinned off them. People would collect the rootbark that way," he says, as he takes a break from spreading manure on a rye field.

The popularity of sassafras tea has dipped sharply in the past decade, as government warnings and regulations have frightened some from its consumption. Several years ago, the U.S. Food and Drug Administration banned sassafras tea for sale in interstate commerce for alleged carcinogenic properties.

Safrole, part of the volatile oils of sassafras, was found to cause liver cancer in rats when it made up .5 to 1 percent of their total food. Some health food stores today sell safrole-free sassafras extracts for worried consumers.

Homemade sassafras tea continues to appeal to mountain residents of all ages. Rosie Smith of Banner Elk, North Carolina, drinks it occasionally on a cold winter's day.

"Yeah, I enjoy it and drink it when I want some. If we decided to give up absolutely everything that somebody decided was bad for us, we'd die of starvation or dehydration," she says.

A co-worker of hers, Richard Jackson, digs up the roots to send dried root bark to a friend in Florida who has had part of his stomach removed. Sassafras tea soothes his digestive tract.

Sassafras trees can be found in all our mountain counties, often growing in thickets since it sends out sucker roots. Careful digging with a shovel will uncover the roots, which can be taken to make the tea, either by peeling the bark to steep in water or by adding the entire root to the pot.

When you pull the root from the ground, you will know why Columbus welcomed the fragrant breeze near the end of his long journey, and the sweet aroma of the boiling tea will tell you why sassafras is an enduring part of our American heritage.

## FLOWERS OF THE SUMMER PASTURE

Nature celebrates the summer season by pouring forth an abundance of life. A visit to a rural pasture reveals this profusion.

While a distant perspective shows a general greenish hue, a closer look opens a world of variety and multi-hued beauty. White flowers, red flowers, blue flowers, yellow, green, purple, and pink flowers lurk among the verdant grasses.

Beauty is just part of the story. Many of the plants have served as food, medicine, or dyes, and some have symbolic value. And of course, most are flavorful munchies for the cattle, sheep, goats, or horses who find their homes in the pastures.

Clover is one of the most common of the plants that flourish in summer months. Red, yellow, white, and hop, the various clovers are a favorite of herbivores, from the small rabbit to the large work horse, and the tastiest part is the fragrant flower, which makes an appetizing garnish for human salads as well.

Medicinally, clover, especially the red variety, has been an important part of the pharmacopeia for centuries. As a tea, it is used as a blood purifier and to relieve bronchial problems. As a poultice it will reduce swelling and ease stings, and is reputed to help malignant tumors of the skin.

While clover crawls along the ground, yarrow holds its white-flowered head high

*Ox-eye daisies bloom by the barn.*

among the grasses and weeds. Its botanical name, *Achillea millefolium*, gives a clue both to its appearance and its uses.

*Millefolium*, thousand leaves, refers to the many fern-like leaves that grow along its strong stem. Equally many small flowers grow on the tops of the stems to form broad white or pink clusters, so it makes an attractive indoor arrangement.

*Achillea* comes from the ancient Greek warrior who reputedly discovered its medicinal value of stopping violent bleeding and acting as an anesthetic. Its folkname, nosebleed, also comes from its ability to hasten clotting. As a tea, it is an effective remedy for the common cold and flu.

In addition to its beauty and medical effectiveness, yarrow is used by the Chinese in divination. They dry the tough stalks to use like Western pick-up sticks, dropping them to get directions from their sacred book, the *I Ching, The Book of Changes*.

Similar in appearance to yarrow is Queen Anne's Lace, a beautiful flower from a distance or up close. Its large flower that tops the stem is composed of smaller flower clusters that are composed of even smaller flowers. American poet Richard Wilbur begins his poem "The Beautiful Changes" with a description of wading through a meadow,

"The Queen Anne's Lace lying like lilies
On water; it glides
So from the walker, it turns
Dry grass to a lake."

*Queen Anne's Lace*

*Bladder Campion*

More prosaically, Queen Anne's Lace is known as wild carrot, for it is the progenitor of the cultivated root familiar to all.

Pasture flowers familiar to most are daisies and black-eyed Susans. These cheerful blossoms nod at the tops of their long stalks where children love to pluck them. Black-eyed Susans have large blossoms of deep yellow with dark brown middles. Daisies have white petals surrounding a yellow center.

Nicholas Culpeper, a seventeenth-century herbalist, wrote that the Ox-eye daisy "is a wound herb of good respect, often used in those drinks and salves that are for wounds, either inward or outward. The juice or distilled water of these, or the Small Daisy, doth much temper the heat of choler, and refresh the liver and other inward parts."

Similar in appearance to these is Fleabane, a plant with many small, daisy-like blossoms. Its name comes from its reputed ability to rid a house of fleas when its dried blossoms are scattered throughout. During earlier times when floor covering was often dried rushes, this would have been more practical than in today's world.

More appropriate for the frenetic present is St. John's Wort, which has bright yellow blossoms. Because it is said to blossom on June 24, St. John's Eve, it was given its holy

name. Culpeper's comment on this herb is that "a tincture of the flowers in spirit of wine is commended against the melancholy and madness," and folks today continue to take it to relieve depression and nervousness.

Bright blue blossoms identify the chicory plant, but you have to look in the morning to find them. The plant's many blossoms begin to open soon after sunrise, and by the afternoon have closed for the day. While chicory leaves and its roots can be eaten, the most common use of the plant is as a coffee additive or substitute, using roasted roots.

Even simple pasture grasses can dazzle the eye if looked at closely. Timothy, an excellent forage and hay for horses, looks like a small, green cattail when seen from afar, but closer inspection reveals many tiny blossoms dangling from the cylindrical top.

Bladder Campion, rough-fruited cinquefoil, horse nettle, curly dock, Deptford pink, evening primrose, various mints, and many other flowers with interesting names and intriguing stories make a meadow a book to spend many hours reading and gathering lore.

Whether it's a daisy cluster by the chicken house, a stalk of Fleabane by the gate, or a patch of yarrow in the middle of the field, the flowers of summer bring beauty, sweet scents, and a whiff of heritage with their blossoms.

*Tiny blossoms on Timothy dangle next to Primrose.*

# DAHLIAS

Andrew Clark and his wife, Mary Lou, are partial to dahlias. They are also partial to company. So when they set out their beds of the brilliant flowers, they also set out a sign on the highway inviting folks in for a visit.

While the couple live in Unicoi during the work week, on weekends they drive up to their place at Iron Mountain Gap and hang out their sign that says "Flower Garden." Then they leave the gate to their long gravel driveway open. Hundreds of visitors find their way to the dahlia beds as large as a football field that line the ridge around the Clark's mountain house.

"I have no idea how many they are, but they's a good acre of them all together," says Andrew Clark, standing waist deep in dahlias, talking with folks who've come up to see the flowers.

"I just like people to come up and see them. People comes until dark," he says, stepping aside to let a car pass down the two-track dirt road.

Visitors come and go throughout the warm Sunday evening. Some of them know the Clarks, and stand to chat awhile; others simply drive up, look around, then depart. The guest book for September holds 152 names, and the

*Andrew and Mary Lou Clark stand waist deep in dahlias.*

*Yellow dahlia in full bloom next to a bud.*

month is not quite over. They are all impressed by the staggering number of blossoms. But Clark is not.

"Next year I want that whole ridge filled full of them," he says, gesturing up the ridge that runs to the old cemetery where there are another hundred yards or so that could be bearing dahlias.

The Clarks like the dahlias because once they start blooming, they keep on blooming until a freeze. They say that you can get a hundred blossoms from one plant.

"Any other flower, from a week's time it's gone. These just keep on blooming," says Mary Lou, holding a grapefruit-sized yellow blossom in her hand.

Although they like the red ones, they have about a dozen different colors in their patches. Yellow, white, pink, purple, red, and salmon are the single colors, and reddish with yellow, purple with white, purple with yellow center, and other combinations fill the extensive beds.

While they know the names of some—"reddish with a yeller center is called a sunset"—they are more concerned with the beauty than the names. "I don't know just all of

them," says Mary Lou. And they do prefer the red.

"I'd like to get a solid full run of red ones," says Andrew, holding a huge red blossom as big as his head up to his face.

Andrew Clark has spent four years buying bulbs to fulfill his flower fantasy. He and Mary Lou talk about selling some, but so far, "I never have sold any yet. I've always bought," he says, then grins sheepishly.

Each spring he sets them out, and each fall he digs them up and stores them in the cellar of the large log house he has built.

"Digging" is done with a tractor, for the flower beds extend for many yards. In the spring, he plows them first, then discs the patches before laying out the furrows where he drops the bulbs. He then covers them with the tractor.

In the fall he plows the bulbs out with the tractor, then hauls them to his basement in a truck. They make quite a pile.

"I've got a big basement. The pile's about 8 foot wide, 6 to 7 feet high and 10 to 12 to 14 feet long. I dig them up after the first frost hits," he says, hitching up his overalls.

Already the flowers have suffered some from a recent windstorm, but the numbers and the beauty still overwhelm visitors. With frost expected soon, the Clarks urge folks who would like to see the sight to get on up the mountain as soon as possible.

"We like folks to come visit," Andrew says, holding up the large red blossom. "But they'll only bloom till the frost kills them down."

The Clarks' flower garden is located just on the Buladean side of the North Carolina-Tennessee border at Iron Mountain Gap, about 17 miles from Bakersville. On the weekend if the Clarks are at home, you'll see the "Flower Garden" sign on the left as you ascend the mountain on North Carolina Highway 226.

# GINSENG

Under the shifting shade of hardwood trees, a man kneels in the undergrowth of the forest fringe. With a sharpened stick, he carefully digs, following the stem of the foot-tall ginseng plant down into the rich soil. Its green leaves and red berries nod back and forth as he reaches the root top. Patiently he works the dirt away from the thick root, taking care not to tear the delicate threads that penetrate the soil. Finally he pulls the cream-colored root free.

He takes great care, because instead of collecting the valuable root for sale, he is transplanting the rare plant to his own woods, where he can attempt to ensure its continued existence.

Every year at the end of summer, this same process is repeated throughout the Appalachians, as mountain folks harvest the ginseng plants that have for many generations been a part of the culture of the people. For most, the roots are collected to be dried and sold, but increasingly, concerned folks are gathering to save rather than to sell.

*Ginseng berries rise above symmetrical leaves.*

Over 200 years ago, Andre Michaux taught the settlers around Grandfather Mountain how to gather and prepare ginseng roots for export to China. Since that time many tons of the valuable plant have been taken from the wild, dried, and sent to that distant land.

Today, each year thousands of pounds of the dried roots are sent to Hong Kong and Singapore. Many people think that the harvest has become too successful, threatening the very existence in the wild of *panax quinquefolium*, American ginseng.

*Mitchell County man carefully removes roots from soil.*

"Everybody out there seems to be saying it's becoming scarcer," says Marjorie Boyer, ginseng coordinator for the North Carolina Department of Agriculture.

According to Boyer and Tennessee Ginseng Coordinator Josh McKee, while the harvest has held steady for the past several years, the figures may not show the actual state of the wild crop.

"I've heard some complaints by dealers of illegal digging out of season and people buying out of season. They're mainly wanting me to do some field work to see what is really going on," says McKee, who is new to the ginseng field, having been in his position for only a couple of months.

Problems range from poaching in protected areas, such as the Great Smoky Mountains National Park, to out-of-sea-

son gathering and selling, and organized hunts that sweep an area clean of all ginseng, mature and immature.

In North Carolina, gathering wild ginseng, except for transplanting, between April 1 and August 31 is forbidden by law; in Tennessee, the season is closed between January 1 and August 14.

But everyone in the mountains knows the law is not strictly enforced, and therefore is not honored, except in the breach, by the majority of those who collect the plant.

"Some old-timers and others continue to gather responsibly, but there are definitely some people really making it an organized thing, getting families together and sweeping an area of everything," says Boyer, exasperation and concern in her tone.

Some mountain folks are also worried that an important part of their heritage is disappearing. The man gathering the plant above is one of these.

"When I was a kid we used to try to find it. We dug ginseng, blood root, May apple, and cohosh. In the winter time, we picked bam (balm of Gilead) buds. We used the money for Christmas.

"As a boy, you'd buy firecrackers. When you got a little older, you'd buy a present for your girlfriend," says the dig-

*Ginseng root*

ger, as he pauses from his task.

This man doesn't want to be identified for fear that his plants will be taken by an unscrupulous gatherer. The bed of ginseng he is digging up is one that he has kept track of for years, but the piece of property that it stands on is being sold by his neighbor, who asked him to dig it so it would be preserved.

"I'm more interested in preserving them than converting them into a little money. Ginseng is part of my Appalachian heritage, and I want my children to share in that. I want to teach them the desirability of conserving nature as we found it," says the native of Mitchell County, as he gathers his plants into a bundle.

Taking them to a small piece of woods behind his house, he digs large holes, then carefully sifts the soil down around the roots of the plants. In a short time, they stand tall and healthy once again, the leaves and berries swaying in the shifting breeze.

He brings his daughter, a graduate student in her early 20s, out to see the plants, so she will know what ginseng is.

"I didn't know what it looked like before. I thought I did, but it was the wrong thing. I do know now," she says, as she kneels beside one large plant to examine the symmetrical leaves and the berries ripening from green to red.

# AUTUMN FLOWERS

While the Southern Appalachians are justly famed for the annual spectacle of the autumn leaves, an equally beautiful burst of nature's exuberance often passes unnoticed.

The wildflowers of autumn quietly flourish all around the mountains, matching or outdoing even the celebrated flowers of spring. Open fields wear colorful covers of bright yellow goldenrod, splashed with the patches of blue asters, purple ironweed, and lavender Joe-Pye weed.

The beauty of the goldenrod is tarnished somewhat by its undeserved reputation as a major contributor to hay fever and other allergies. In fact, the pollen from goldenrod is sticky because the plant is insect-pollinated rather than pollinated by the wind, so it doesn't get up in the air. Ragweed is the culprit.

Asters come in white petals and in various shades of blue surrounding central discs of yellow, purple, or brownish-red. Like goldenrod, when the asters arrive they seem to be

*Asters*

*Butterfly sips on Iron Weed blossoms.*

everywhere. Their name comes from the Greek word for "star," and their numbers as well as their shape show the connection.

Ironweed derives its name from the toughness of its stem. Its flowers are bright purple or bluish-purple or reddish-purple. The blossoms cluster at the tops of the stems where they glow throughout the first cool days of fall.

Joe-Pye weeds are common, but to see the six- or-seven-feet-tall plants blooming with jewel-like hummingbirds sipping from the small lavender blossoms that grow in large clusters makes you doubt the "weed" part of the name.

The Joe-Pye part comes from an Indian, Joe Pye, who trav-

eled about colonial America instructing the settlers in the herb's effectiveness in alleviating typhoid fever.

Other flowers which flourish in the open are Queen Anne's Lace, yarrow, chicory, jewelweed, and bull thistle. The first derives its name from the queen of James I of England. According to legend, Queen Anne challenged her ladies-in-waiting to a contest to see who could duplicate the beauty of the flower.

It is also known as wild carrot and is the progenitor of the cultivated carrot we eat today. Queen Anne's lace has a long taproot that is tough and bitter, but edible. From this root comes a long, green stem topped by the beautiful, lacy white flower composed of many small flowers.

Growing in damp places along creeks or surrounding springs are the glowing jewelweed plants. The bright, spotted orange or yellow blossoms dangle in profusion from the watery stems and branches.

The pollinated flowers turn into seed cases that explode when touched, thus giving the plant its other name, touch-me-not. By whatever name, it is a well-known preventative and remedy for poison ivy when the juicy stems are

*Gentian*

rubbed on the exposed areas of skin.

It's best to avoid any contact with bull thistles. While the large pink blossoms are beautiful to look at, the sharp spikes of the plant are dangerous to man and beast alike. Frantic fall grasshoppers occasionally impale themselves on the stiff, sharp thorns.

Twining around fences and cornstalks, wild morning glory vines bring beauty with their heart-shaped leaves and dew-sprinkled blossoms. This plant was introduced from tropical America as a garden ornamental but has escaped to become part of the wildflower community.

Another flowering vine is virgin's bower. It winds its way through weeds, shrubs, fences, and trees, covering them in its thin feathery blossoms that look like puffs of smoke from a distance.

Under the gradually thinning forest trees, such plants as turtlehead and gentian bring color to the forest floor, as the changing leaves do to the canopy. The pink or pinkish-purple blossoms of the turtlehead look like the heads of turtles, while the deep purple flowers of the gentian look like darkly glowing Christmas bulbs.

The many flowers of autumn are nature's last hurrah of life before the cold of winter shuts vitality down. Bees and other nectar-gathering insects need the bounty of blossoms to fill their hives with honey to overwinter. Hummingbirds load up to sustain their migratory flights.

Enjoy this final fling of the vegetation. Open your eyes to the beauty of the "weeds" that fill the open spaces of the mountains and the last flowers hidden on the forest floor.

If you want, a good field guide to wildflowers will tell you their names and lore, but they will entertain you all on their own.

# IVORY GAIL: HERBALIST

While many experts have said that people during this past century have learned more than in all previous centuries, it may be equally true that more has been forgotten in this century than in all those that went before.

Natural knowledge of plants and their uses that had been passed from parent to child for untold millennia has largely been lost over a relatively few years, as new ways have rapidly replaced the old. What was necessary for survival in Southern Appalachia at the end of the nineteenth century has become lost in the progress of the twentieth century.

Some folks still remember the culture, but few remember the specific plants and recipes and ways that made mountain forests a farmer's drugstore, grocery store, and playground.

Ivory Gail Hoilman grew up with a richness of life based on knowledge and love of the natural world of the high mountains behind the Blue Ridge. Her grandparents and parents lived in harmony with that world and created an abundant life from what was given them by the land. Yet she has lost much of what she experienced.

One of 13 children raised on Dave and Hassie Hill's small farm at the bottom of Greasy Creek in the Buladean community, Ivory Gail has spent many years of her adult life trying to recapture what was lived so effortlessly by her forebears.

*Ivory Gail Hoilman squeezes soothing juices from jewel weed.*

While she traveled

*An old photograph of Grandma Hill, the herb woman.*

through the woods with her Grandma Hill and sat in her kitchen filled with the smells of curing herbs, Ivory Gail was too young to learn the specifics.

"Grandma Hill knew every medicine plant there was. I loved going to the woods with her, but I didn't realize how much I would want to know later. She died when I was nine. It was just fun then, and I never learned what she knew," she says, sitting in the kitchen of the house her father built.

Her grandparents lived not far away in the big bottom under the Roan. Ivory Gail spent many hours with her grandmother. While she learned to love nature and respect her environment, she never picked up the lore and recipes that made Grandma Hill a respected herbalist in the community.

"She'd take me with her, and, well, Daddy, all the time he was growing up he helped her gather her medicine plants

and make the medicines. Granny said she didn't doctor as much as she made medicine for people to use.

"She midwifed some, but mostly people would come to her to buy her herbs and medicine plants. Also, she sold herbs and roots at Orville Garland's post office and trading store," says Ivory Gail, who then smiles at her mother and brother Ralph, sitting in the kitchen with her.

The young mountain girl enjoyed the freedom of roaming the hills with her father and her grandmother. She learned to recognize important plants, but mostly she absorbed the wonder of the natural world, emotionally and physically.

"I was a real hillbilly gal with Cherokee spirit. You couldn't keep me out of the woods," she says, shaking her blonde ponytail.

Dave Hill and his mother also instilled in her and her siblings a respect for the fragility of nature and knowledge of the necessity to preserve what was given.

"Grandma Hill was an early environmentalist. She taught Daddy, and he taught us never to take ginseng out of season, to wait until it is ripe. Then you crush the berries and plant the seeds.

"I've heard Daddy many times say, 'Don't take nothing from this old earth without putting back,'" she says.

The woods provided recreation as well as medicinal herbs and food. After working in the fields all day, a jaunt into the woods was restoring to both parents and children.

"Daddy, his idea of a vacation from farm-

*Ivory Gail Hoilman shows how a jewel weed blossom transforms her fingertip.*

ing was a 20-mile ginseng hike, but along the way he would point out every plant and tell what value it had, how it would help people. I enjoyed the walk but never paid much attention," she says.

Her brother Ralph also remembers the walks with their dad, who took him and his twin, Ray, along on his herb gathering expeditions.

"He'd take you anytime you wanted to follow him. He'd tell me and Ray every plant there was, but we wouldn't listen. We just wanted to run and play and be wild. There was a lot he told us about. I can recognize them, but I can't remember everything he told me," says Ralph, who continues to farm on the lands under the Roan.

Every spring the family would be dosed with tonics from Grandma Hill's recipes. Again, the recipes were passed to Dave Hill, who used them to care for his family, but the line stopped with him.

"Daddy every spring toniced us with sassafras root. He made a wonderful tea that tasted as good as any root beer you ever drank. He sweetened it with honey. He also made one with spotted wintergreen, Indian physic. They made a tonic from the roots and leaves," she says.

And then there was the worm tonic. Both Ivory Gail and Ralph remember that well. Their faces turn a bit green with the memory.

"They scraped the bark from peach trees and wild cherry and boiled it. After they boiled that down, he would take a few drops in a teaspoon full of sugar and make us take it," says Ivory Gail.

"Yeah, that sugar was to make it go down," says Ralph, making a wry face.

"But it worked," says his sister.

Her mother Hassie taught her some uses of plants that are purely for fun. Dave Hill was strict with his girls, not allowing makeup or fancy airs. But his wife knew girls love a bit of color.

"Daddy detested makeup, and little girls love it. So Mamma showed us all the plants we could use to dress up

with. She taught us how to use touch-me-not blossoms on our fingertips to look fancy," says Ivory Gail, taking one of the orange blossoms and slipping it over her fingertip.

Although she enjoyed the life on the farm and in the woods, Ivory Gail felt the need to see the world, and for several years lived off the mountain, getting as far away as Germany. Yet she always felt the pull of her home.

When she returned, she went to Mayland Community College to study horticulture to try to rediscover some of what she had lost as a child. Although she received her degree and today teaches continuing education courses in rare plants and medicinal herbs, she has only regained a small part of what has been forgotten.

"I always enjoyed these things, but I never really did anything about it until I went to horticulture school and worked with Dan Dunford. I read plant books to try to learn things that I could have gotten from Grandma Hill," she says.

Through her adult education, she has learned much about natural dyes, natural medicines, edible wild plants, and rare and endangered species. She knows how to use such plants as wooly mullein, Joe-Pye weed, ginseng, and others. She enjoys passing the knowledge on to those who take her classes. But she knows that much has been lost

"Oh, my grandmother's gingerbread. She made it with wild ginger; the way her kitchen smelled was wonderful. But nobody ever got her recipe, and I've never tasted any that good since," she says, and sighs for what has been lost.

# HERITAGE APPLES

Our mountain ancestors have left us many tantalizing traces of their existence. One of the most palatable is the abundance of apple trees that thrive throughout the Southern Appalachians.

On old farms, in abandoned pastures, beside forgotten roadways, the most American of all fruit trees maintains a tenacious hold. Some are old beyond memory, planted by our forebears and tended for generations; others are relatively new growths that have sprung from chance-dropped seeds.

From entire orchards to lonely single trees, apples provide both animals and folks with free snacks during the autumn months. Some, such as the Early Transparents, bear their tasty burdens as early as late June, but most have ripe fruit at fall harvest time.

But don't expect to find the flawless, waxed globes that you see in supermarkets. These apples, unless tended by some careful farmer, tend to be spotted, sometimes misshapen. Yet they can be as juicy and tasty as the best the stores have to offer, and they are free of pesticides, as organic as you can get.

Old timers and experts can often iden-

*Lee Hughes, an apple grower throughout his life, knows his heritage apples.*

tify the varieties that these heritage trees bear. Wolf River, Virginia Beauty, Pound Pippin, Arkansas Black, Crow Egg, Red Pippin, Sheepnose, and others, as well as the Golden Delicious, McIntosh, and other more common varieties tell of those who preceded us.

*A bowl of heritage apples.*

An old Wolf River tree bears annual crops for me on the edge of a pasture. While the trunk is largely rotten, spreading limbs hang heavy with large yellow and red globes. One good-sized Wolf River plucked off the branch will make a meal in itself, and nothing makes a better apple pie.

It takes little time to fill a large bag with these big apples. The younger, lighter members of my family climb into the tree to toss down the ripe fruit. Competition from birds, squirrels, deer, raccoons, and other wild neighbors will quickly deplete the tree, not to mention the assaults by the horses who rub back and forth on the branches to bring the apples down.

Lee Hughes, who has lived his life in Buladean, has some Wolf River trees that have supplied him for much of his 88 years. In the middle of his bean patch, a large one showers the ground with hundreds of apples. A long-time orchard keeper, Lee and his wife, Vergie, have trees planted and grafted by Lee's father, who farmed before him.

A favorite Pippin tree shows the graft line where his father set it. Now the tree is over two feet in diameter and towers above Lee. Nearby are several Virginia Beauty trees that are older than he is. Reputedly the tastiest of the eating apples, Virginia Beauties are highly sought after.

A couple of old Virginia Beauty trees grow near the head of Blevins Branch. I try to visit them each fall to get a bag or two of the sweet, crisp apples that are easy to identify because

of the distinctive tan splotch that colors the dark red apple around the stem.

Some of the old-time apples are difficult to identify by name, but their differences are clear. Walking from tree to tree in my pasture, I can get about a dozen distinctive kinds, ranging from dark red through pink to golden to grass green.

From quite tart to extremely sweet, they have many unique flavors. Some are smaller than tennis balls, while others are double handfuls. A few will mellow overnight, while others will keep through the winter. A large bowl of them shows God's bounty and variety.

Other than God, I don't know whom to thank for them. Some of the largest trees are over three feet in diameter and were probably planted and grafted long before I was born. Others have sprung up in the past few years, as I can span their trunks with my two hands. They are probably seedling trees.

"Seedling apples are ones that comes from the seed. They might be any kind. It'll bear apples, but it'll just be anything. Mostly you want to graft trees for sale apples," said Lee Hughes, glancing into a large bag of miscellaneous apples I brought him to identify for me.

He puzzled over most of them, making guesses but not prepared to give an authoritative answer. He was sure of the Wolf River and an Arkansas Black. He was pretty sure of Golden Delicious, but the rest he wouldn't hazard a guess about.

Many nameless Johnny Appleseeds have left their marks on the mountains. Their monuments are apple trees that bring beauty to each season. In winter, their bare branches stand black against the snow, stark etchings created by the hand of time.

In spring, their pink and white blossoms shed light perfume, one beautiful sign that the tide of the seasons has turned. Their green leaves throw deep shade in summer. And the vari-colored fruit brings in the autumn.

Our inheritance comes in many forms. Apple trees are a simple part of it, but enduring and sustaining

# FLAT ROCK TRAIL

As the fall season brings spectacular beauty to the forests along the Blue Ridge Parkway, visitors flock to the mountains to share nature's annual gift. While many keep to their cars for a rolling review, others find trails along the way to take them deep into the season.

At milepost 308.2 between Spruce Pine and Linville, the Flat Rock Trail provides hikers with an easy, fulfilling trip into autumn when the leaves turn. The trail takes about 30 minutes, if you simply plow ahead to cover the ground, but if your intentions are to savor the beauty, the trip will last much longer.

While the destination, Flat Rock, is worth the effort in itself, the hike there and back is its own reward. Small, interpretive signs along the way tell interesting bits of the story of the Southern Appalachian forest, pointing out trees and plants while telling of their significance to the mountain dwellers of days gone by, as well as to us.

The first plaque on the trail encourages you to open your mind and heart to the woods you traverse, to learn the lessons that the beauty so effortlessly presents. The quote from David Brower reminds us that we are part of the natural world, not simply visitors to it:

"It is fair to remember that this is not a land that belongs to us. We belong to it.

*Flat Rock pedestal has bronze sighting plaques to identify the surrounding mountains.*

Its trees can teach us tenacity and patience and serenity and respect.... Wildness made man but he cannot make it. He can only spare it."

Next, a plaque tells the story of the chestnut oak, revealing that "the bark of this tree, rich in tannin, was ground in bark mills by early settlers and used in curing leather." It also points out the distinctive shape of the leaves with their smooth, scalloped edges.

Looking up the trunk of the tall tree, you can see the leaves on high, turning a rich tan-brown, then find some specimens on the ground to compare with others, such as maple leaves and poplar leaves that have fallen with the season's magic.

Further along the trail, you come to a plaque planted in front of the rotting stump of a once-large red oak. It asks the question, "This forest is still luxurious, but what was it like before the coming of the settlers?"

It then states, "Large trees like this Northern Red Oak must have been very common." Yet even this specimen has been brought to the earth, as time and change continue their inexorable movement through the forest.

The message before a small American Chestnut tells of the blight that has stricken the species, destroying the large trees that once dominated the forest. A hopeful sign is that "the roots still cling to life and persistently send up new shoots," like this slender specimen.

Other species pointed out along the trail to the rock are mountain winterberrry, a cucumber tree, and galax, whose round leaves turn reddish bronze at this time of year to form a distinctive carpet of the low-growing plant.

The story of witherod tells of the days when the forest served as the people's pharmacy. Known as shonny haw, the plant's bark, when brewed into a tea, provided the settlers with a cure for fevers and the colic. Sold to herb houses, the plant gave the mountain folks a source of much-needed cash.

Most folks linger long on the Flat Rock which is the trail's destination. This massive outcrop of quartzite interlaced with

*Grandfather Mountain looms in the distance past Flat Rock.*

ribbons of durable white quartz provides striking views of several surrounding mountains, as well as the Linville Valley, which lies below.

An unusual feature of Flat Rock is that it has two pedestals with bronze sighting plaques that make identifying the surrounding mountains an easy task. A raised central cone with surrounding smaller cones gives you lines of sight to the Black Mountains, Roan Mountain, Yellow Mountain, Hawk Mountain, Big Yellow Mountain, Hump Mountain, Grandfather Mountain, and others.

At any time of year the views from Flat Rock hold visitors, but at this season they are the stuff that trips to the mountain are made of. Video and still cameras that have been carried over the rest of the trail emerge here to record the

beauty. Many folks simply sit to soak in the awe-inspiring sight.

The trail back to the parking area loops around through another section of the forest, taking you past hobble bushes, striped maples, Eastern hemlocks, Fraser magnolias, and flaming red maples, "the color king of the Southern Mountains."

A large burl growing on a red oak is identified. These "cancer-like growths," were used in the past by the settlers and continue to be used today by craftsmen for making distinctive wooden bowls and other such containers.

The final stop on the trail is by a white oak that lies recently uprooted. Ironically, the plaque describes it as "king of mountain trees," saying, "wherever hardness, strength, and lasting qualities were needed, early mountaineers sought out this tree for all sorts of implements and household necessities."

The cool temperatures and fall colors make this an excellent time to visit the Blue Ridge Parkway. While you are there, be sure you stop to sample some foot trails, as well as the hard-topped roadway. Allow yourself the time to feel the part of nature that you are.

# HAWTHORNS, DOGWOODS, AND WITCH HAZEL

As the colorful leaves fall with the winds and frosts of approaching winter, other signs of color linger in the stripped woods. Hawthorn and dogwood berries gleam in the sunlight, and the blossoming yellow flowers of witch hazel seem to confound the season.

In lean year's especially, with the mast crop practically non-existent in the higher mountains, the berries of the hawthorn and dogwood trees feed a variety of birds and mammals. The hawthorn's haws also provide palatable snacks for folks.

Early on a crisp morning, as rain clouds approached, I watched cardinals, towhees, and sparrows hop about the limbs of a tall hawthorn as they ate the large yellow and red berries. Later in the day as the drizzle fell, a small flock of mourning doves searched beneath the tree for the fallen fruit.

From my office window at Lees-McRae College earlier this fall, I watched robins spend the day robbing a dogwood tree

*Sharp thorns protect hawthorn berries.*

*Blossom and seed pods on witch hazel.*

of its bright red berries. Now only a few scattered remnants glow against the blue sky.

Bears, deer, squirrels, and other mammals also love the taste of the autumn berries, especially the hawthorn's abundant fruit. These berries range in color from bright red to yellow, and in size from that of large cherries to quite small. Some taste tart and lemony, others sweet and sugary.

Native Americans and early settlers joined the birds and animals in enjoying the fruit of the hawthorn. Eating them raw, cooking them, and pounding them with meat to make pemmican, the early Americans appreciated the tree's bounty. Some folks also made a palatable, heady wine from the hawthorn.

Both the hawthorn and the dogwood hold important places in folklore. Since the times of ancient Greece, the hawthorn's flowers have crowned the bride at weddings and its wood has made the marriage torch. Perhaps the long, sharp thorns that arm the tree, together with its beautiful, sweet-scented white flowers make it an apt symbol for marriage.

For Celtic peoples, the hawthorn deserved protection, and

if it were cut down, bad luck would pursue the destroyer. In England, Henry VII found the fallen crown of Richard III in a hawthorn at the Battle of Bosworth Field and adopted the thorn as his emblem.

These same thorns in Christian legends formed the crown of thorns at the crucifixion and thus are potent and miraculous protection against evil. Similarly, in early Rome the hawthorn was a charm against witchcraft and sorcery. In the cradles of babies, its leaves barred malign influences.

The dogwood also has long been associated with the crucifixion. According to the legend, the cross was formed from the wood of the dogwood tree, that in those times grew as large as an oak. Jesus pitied the tree for its role in his passion, so he gave it special qualities as an emblem of his suffering.

The blossoms of the dogwood form a cross, and in the center of each one is a small crown of thorns, and on the edges of each petal are nail prints. In the fall, the bright red berries represent the drops of divine blood shed for our salvation.

While the berries are the last stage in the seasonal cycle of the trees, the blossoms of the witch hazel, despite their unseasonable appearance, are the beginning of the life cycle of that shrub.

The bright yellow tendrils appear as the leaves fall. These are the flowers that form the seed pods. How they are pollinated is a mystery, as few bees or other insects are active at this time of year. But that they are successfully fertilized is proven by the seed pods, the product of last year's blossoms, that reach maturity at this same season.

If you bring a branch of the bright blossoms into your warm house, you'll be surprised by a popping sound as the pods explode to send their black seeds sailing through the air. You can notice this same phenomenon if you spend some time by a witch hazel bush on a warm fall day.

Surprisingly, the plant has nothing to do with witches, at least the Halloween kind. The branches have long been used by water witches in their dowsing for not just underground springs, but also for gold and other valuable metals.

As a medicinal plant, witch hazel has been used by millions of people for many years. It still can be found on pharmacy shelves in an alcohol mixture promising relief from aches and pains, as well as razor burn and bad breath.

Each season has its beauty and mystery. Even as the grey days of winter steal into the mountains, hawthorn, dogwood, and witch hazel trees show their colors with their promises of ever-renewing life.

# PINNACLE OF THE BLUE RIDGE

As the last stubborn leaves whirl to the ground carried by the crisp winds of late autumn, the Southern Appalachian forest assumes quite a different character than it displays in summer. Your eyes see much farther through the now naked trees and through the atmosphere that is now often clear of haze.

While a drive along the Blue Ridge Parkway gives you an opportunity to appreciate the present clarity, a hike on one of the trails that depart the roadway gives you a much more intimate look at the season. Located near the turnoff to Mount Mitchell State Park, the trail to the Pinnacle of the Blue Ridge is an excellent one for seeing both the changed forest and beautiful vistas stretching for miles and miles.

The trail to the Pinnacle runs along the boundary line between the Blue Ridge Parkway land and the Asheville Watershed. Frequent posters and metal signs warn against crossing the line to enter the watershed. Some are many

*Mountain ranges run to the horizon from the Pinnacle.*

years old, some fairly recent, but all threaten some kind of retribution for anyone who crosses the line.

A dilapidated barbed wire fence runs along the trail, which keeps roughly to the ridgetop, so while the trail is not clearly marked by signs and is faint in places, it is still fairly easy to keep on it. But if you lose the path, climb straight up, for the Pinnacle is just what its name proclaims.

The trail begins near the parkway at Toe River Gap. A metal pipe gate blocks a gravel road that leaves from the eastern side of the parkway just north of the exit to Mount Mitchell. The trail climbs the bank of the gravel road to run through a grove of hawthorn trees about ten yards from the gate. The bright red berries of the spiked trees lie among the leaves on the ground.

Large red spruce and Fraser fir trees that naturally grow above 5,000 feet rise all along the ridge, showing how high the elevation is. The Pinnacle is one of the peaks measured by Arnold Guyot in the 1850s.

This Swiss-born geographer explored the Appalachian chain from New England to the South. He was one of the first to proclaim the Black Mountains the highest chain in the East, and his map published in 1860 was the first to accurately depict that range and its relationship to the Pinnacle of the Blue Ridge, which he labeled the High Pinnacle.

Not far along the trail, you come to a clearing overgrown with raspberry and blackberry vines. Fortunately, because of the elevation, these canes have few if any sharp spurs to hook you as you pass through. The clearings along the way are remnants of the pastures where settlers from the North Fork Valley used to graze their livestock during the summers.

The North Fork community was a thriving one until they were evicted by the Asheville-Buncombe Water Authority. In his book, *This Was My Valley*, Fred M. Burnett describes the farming and hunting community that existed since the turn from the eighteenth to the nineteenth century in this rich land. He describes the bear stand that his father, Lafayette (Fate) Burnett would always take on the Pinnacle:

"From the high rock at the edge of a dense group of balsam

on the north side of the Pinnacle, he could hear in all directions for mile on mile. If the dogs got out of hearing of the half-dozen other standers down in the coves or on the lower ridges, Daddy could usually keep them in touch with the race. His yelling or hollering voice was as clear as a bell and carried far out and beyond and resounded throughout the coves and across the ridges to far distances."

The twisted yellow birches

*Rocks jut from the Pinnacle, providing a panoramic view.*

show the exposed nature of the Pinnacle, and the rhododendron and laurel thickets show why it was, and probably still is, a favorite haunt of bears and wildcats, as well as lovers of scenic beauty. Beds of galax, still green along the trail but a deep burgundy red on the peak, line the trail.

The narrow path climbs steadily for the entire trip of about a mile. The literally outstanding feature of the hike is the peak of the Pinnacle, where bare rocks jut from the blueberry bushes and laurel to provide a panoramic view of the Black Mountains, the Craggies, Grandfather, Hawksbill and Table Rock, and other famous area mountains. The view includes

the now abandoned valleys and coves that form the Asheville Watershed, although the reservoir itself is hidden by an intervening high ridge.

Folks have sought this vantage point for years. In 1915, Johnson City architect D. R. Beeson and East Tennessee Normal School professor C. Hodge Mathes camped near the peak, where Beeson took a photograph and made this journal entry:

"The Pinnacle of the Blue Ridge —the highest point on the whole length of the Ridge —is a little over 5,600 feet in elevation and was just above our camp to the south, and we hiked to the top in half an hour. It's a bare, grassy knob and gives all the view you can wish and in all directions. The hogs worried us some in getting our pictures and the Deacon (Mathes) got so immersed in the scenery that he failed to assist in keeping the animals away from the camera."

While he was mistaken about the Pinnacle's being the highest peak of the Blue Ridge—Grandfather Mountain has that honor—his description of the 360 degree view is accurate, and today there are no wild hogs to harrass the hiker.

Since the Watershed has reached out to take the lands along the Pinnacle, domestic animals no longer graze the rich grasses, so there is little chance of being bothered by hogs or other farm animals. But the views remain as spectacular as ever.

# BRIGHT'S TRACE

The rugged mountains that we live among continue to preserve parts of the past that speak to us of our heritage. While asphalt roads cover many of the old trading paths that brought our forefathers into the area, there are places where we can still tread in the footsteps of our forebears.

One such path is Bright's Trace, made famous in our time by the portion of the Overmountain Victory National Historic Trail that follows it from Sycamore Shoals to the foot of the Blue Ridge. Yet the trail came before the 1780 march and has played an important role in the history of the area for many years.

Over 200 years ago, when the land west of the Blue Ridge was supposedly off limits to white settlers, a sturdy hunter, guide, peddler, and farmer, Samuel Bright, built a homestead for himself and his family on the banks of the North Toe River. More importantly, he established the trading route from an Indian path running from the foot of the Blue Ridge, through the Toe River Valley, over the mountains to the Watauga settlements.

For many years, folks have attempted to trace this path. Each generation produces individuals who feel the pull of the past strongly, and tantalizing clues make it possible to follow much of this historic trail, although parts are lost in the obscurity of the distant past.

Bright's Trace ran roughly through McKinney Gap, along the Blue Ridge to Gillespie Gap,

*Robert Sevier died of wounds received at the Battle of King's Mountain and was buried beside Bright's Trace.*

— 147 —

then down Grassy Creek to its junction with the North Toe River. Turning north with that river, the path followed the rich bottomlands of what became the Wiseman farms in the 1800s near what is today known as Ingalls. In this area, Bright made his home sometime in the 1770s.

Leaving the banks of the river but roughly following its course, the trail reached the point at which Roaring Creek runs into the North Toe. It ascended along this branch to a gap in the Roan Highlands, Yellow Mountain Gap, then descended to the waters of the Little Doe River, to follow the Doe River to Gap Creek, where it ran till it reached Sycamore Shoals.

Today you can travel some of Bright's Trace with near certainty that you are in the footsteps of the past. Other parts of the trail now form the roadbeds for modern highways. Some of the route is conjectural, with various options advanced by enthusiasts, all of whom have some facts to back their beliefs. Common sense and topography can be your guide, as well as oral tradition and historical fact.

From historical records, we learn that Samuel Bright was a Tory, an American who supported the King during the Revolution. Court records report on March 6, 1877: "Samuel Bright, being brought before this Court to answer sundry charges of having committed sundry Misdemeanors against the State by encouraging the Enemies of the State: The said Samuel took the Benefit of the Governor's Proclamation before mentioned and took the Oath therein prescribed and was discharged."

The Governor's proclamation gave amnesty to Tories who would take an oath to support the patriot cause. Bright, being appropriately name, made an enlightened decision.

An irony of history is that the Overmountain Men, whose defeat of Major Ferguson and his band of Tory soldiers at Kings Mountain is considered by many to be the turning point of the war, followed a path blazed by one of their enemies. They also refreshed themselves at his settlement on the North Toe.

On their return from their victory, the citizen soldiers left

*Shelving Rock, near Roan Mountain, Tennessee.*

one of their own in this peaceful spot. Robert Sevier, brother of General John Sevier, died from wounds received in the battle. His comrades buried him in sight of the Yellow Mountain. He rests today in a small cemetery, known for over 200 years as Bright's Cemetery.

Bright's name appears again through legal proceedings when his wife was brought before the local justice of the peace, William Wiseman, for stealing a bolt of cloth from an itinerant peddler. One of the Bright enterprises was a small tavern, or ordinary, as it was then called, where his wife took advantage of her position of hostess to wrongfully appropriate the peddler's goods.

Wiseman convicted her and sentenced her to receive 39 lashes on the bare back, "well laid on." However, while he was willing to make the sentence, he was more hesitant about executing it. He knew that Samuel Bright, who was on a hunting expedition at the time, had the friendship and respect of the local Indians. Wiseman did not want to awaken to a burning house and a scalped skull, so he postponed the whipping.

Probably no one in the area was more relieved than he when the Bright family packed up and left the area, traveling with a family named Grant who had spent the winter with them. Samuel Bright and his kin disappeared from area history as they followed his Trace over Yellow Mountain and into the frontier.

Traveling Bright's Trace today is an adventure, spiced with mystery. While researching the path, my family and I tried over several weeks to follow the old mountain man's footsteps across the Toe River Valley and down into Tennessee. With help from maps, historical articles, and knowledgeable enthusiasts, we had some measure of success.

Aunt Ruthie Houston, who makes her home and business, Sunnybrook Store, directly on the Trace, knows much about the trail. A lifetime resident of the Toe River Valley, she and her late husband researched the past on foot and through old documents and interviews. In September 1998, the National Park Service presented her a certificate designating "the Yellow Mountain Trail Segment at Sunnybrook Store as a Certified Segment of the Overmountain Victory National Historic Trail."

Running from the edge of her property through the corner of her store, a sunken trail is a palpable remnant of Bright's Trace.

"Uncle Robert Wiseman let my husband copy some parts of his diary and look over old papers he had. That's how we were able to get it established that this was really part of the first trail," says Aunt Ruthie, as she leads us to the short section by her house.

"It's right here in front of that tree where it's sunk down. It used to run right where that flue is in the store," she says, pointing to a sunken path, then showing how it runs to the back of her Sunnybrook Store.

Looking in the other direction, she shakes her head and says, "Further than that, it's been destroyed. They just recently cut the timber, and it's completely destroyed except right through here."

Where the path leaves her property at the back, it disap-

pears into a recently logged area. Tangled piles of limbs and trash, what mountain folks call brash, obliterate any traces of the trail.

"It was the only road between here and Marion through this settlement. They came across here to take their turkeys and cattle to market, horses, too, anything they had to sell. It was just a horse trail or a foot trail, really, you couldn't get wagons over it," says Aunt Ruthie, whose ancestors used the trail.

*Mitchell Joslin and Aunt Ruthie Houston stand on a segment of Bright's Trace.*

On the front edge of the Sunnybrook property, two markers commemorate the historic foot-and-horse way. One refers to Yellow Mountain Trail, an alternate name for Bright's Trace, the other to the Overmountain Victory National Historic Trail. This portion of Bright's Trace is approximately in the middle of the old route through the Toe River Valley.

At either end on mountain ridges and at strategic places along the trail we found markers. On the Blue Ridge side, at Gillespie Gap near Spruce Pine, North Carolina, a monument with a plaque tells the story of the Overmountain Men's march. While opinions vary concerning where Bright's Trace went from here, most likely it followed what is now the Blue Ridge Parkway, then descended near the Orchard at Altamont at McKinney Gap.

At the junction of Roaring Creek and the North Toe River, a state historical commission sign identifies Yellow Mountain Road, saying, "Along a route nearby the 'Over-Mountain Men' marched to victory at Kings Mountain."

We drove up Roaring Creek until we reached the marked trail after the asphalt turns to gravel. The trail climbs through pastures and woodland beside the gurgling Bright's

Creek. We walked the marked trail along the sunken path that has been traveled for centuries.

At Yellow Mountain Gap, Bright's Trace crosses the Appalachian Trail. The beautiful balds of Yellow Mountain present an open view, while signs tell the story of this gap through which history marched. One sign has a map that shows the entire route of the Overmountain marchers. A side trail leads to Bright's spring, where weary travelers have refreshed themselves for generations.

From the junction of Bright's Trace with the Appalachian Trail, a clearly marked footpath descends into Tennessee three or four miles down through woods, to the top of a farm pasture at the end of Sugar Hollow Road. A few hundred yards down this trail another spring, also called Bright's, drips icy water over a mossy ledge.

Following the asphalt from the farmland, we reached the famous Shelving Rock on the Little Doe River. Here, tired travelers would rest before beginning the last leg of the journey to Watauga Fort, or after their first day's hike of going in the opposite direction. A plaque placed by the John Sevier Chapter of the D.A.R. says, "First night's encampment of Kings Mountain Men. Sept. 26, 1780. They trusted in God and kept their powder dry."

Driving down Gap Creek Road, we came upon a marker set by students of the now defunct Gap Creek Elementary School, and then reached the end of Gap Creek Road where Watauga Fort stood in pioneer times.

At the Sycamore Shoals State Historic Area in Elizabethton, Tennessee, markers, displays, and a reconstruction of the old Watauga Fort bring the past to life, marking the end of the trail.

Our explorations took several weekends, but the experience has its rewards. History becomes tangible, and we have gained a new respect for the sturdy Samuel Bright and for the marchers who won our birthright. All along the trail places captured our imagination, and we will return to look more deeply into the past.

## BIG LYNN TREE

At the tollgates of the road through Little Switzerland stood a true giant of Western North Carolina. Famed for its age and size, the Big Lynn tree was also known for its part in the history of the area.

Standing over 75 feet tall with a circumference of 13 feet at a point 4.5 feet from the ground, Big Lynn was recognized by the American Forestry Association as the champion of its species. As it aged, time and circumstance gradually attacked the venerable landmark, until in 1965 it was cut down after an estimated lifespan of over 500 years.

Perched on the continental divide and the boundary between McDowell and Mitchell Counties, this enormous linden, or basswood, tree overlooked the arrival of the white man, his settlement from the coast to the mountains, and his push up the slopes of the Blue Ridge to establish himself in the rich valleys of the Southern Appalachians.

The tree played a part in one of the most important events

*The Big Lynn stood over 75 feet tall with a circumference of 13 feet.*

of United States history. As the Overmountain Men marched to Kings Mountain to defeat the British in the pivotal battle of the Revolutionary War, they paused at Big Lynn to rest, and to hang a British sympathizer, Nathaniel Riddle.

Afterwards, the mighty linden served a more benevolent role. Nicknamed the "Marrying Tree," it was the rendezvous for couples from the two counties under its boughs to meet and marry. One step placed the couples beyond the legal jurisdiction of wrathful parents.

*Stone markers stood on either side of the toll gate to Little Switzerland.*

The leafy limbs of the mighty linden shaded the toll house of the Little Switzerland Company during the early years of the 20th century. The two stone pillars of the gate stand as reminders of this period.

Even when the trunk of the tree was a hollow shell, Big Lynn stood, battered by winds that tore huge branches from it. Blue Ridge Parkway officials attempted to cut the tree down in 1949 because of the danger it posed, but well organized protests earned it a reprieve.

In 1965, the owner of the Big Lynn Lodge felt so threatened by its weakened conditions that he asked Parkway officials to take it down. The Big Lynn was no more.

However, twin shoots that were growing from its base were encouraged to grow. Today they stand tall and straight themselves, lusty scions of the historic tree.

# HOLLY

How pleasant when night falls down,
And hides the wintry sun,
To see them come in to the blazing fire,
And know that their work is done;
Whilst many bring in, with a laugh or rhyme,
Green branches of holly for Christmas time!
O the holly, the bright green holly!
It tells (like the tongue) that the times are jolly!
Barry Cornwall, 1850

One of the most beautiful trees in winter is the holly. With its bright red berries and its glossy, thorny, green leaves, the female trees capture the eye whether found in field or forest. Its beauty has earned the holly tree a place in the celebration of the season from time immemorial.

Today, and for centuries, the holly has formed a part of the Christmas spirit, but it has a long history even in pre-Christian times.

In ancient pagan cultures, the ever-green nature of the plant and its striking berries symbolized the life of nature. Boughs of the plant were gathered into the temples to remind worshippers that life remained during the deathlike grip of winter and to comfort their gods.

During the civilization of ancient Rome, the holly played a central role in the seasonal celebration of the Saturnalia. Saturn's club, made from the holly tree, vanquished his foes.

Roman Christians adopted the holly bough as part of their Christmas decorations, and ever since, the holly has played a role in celebrating the birth of Christ, as well as his death on the cross.

Legend reports that Jesus Christ was crucified on a cross made of holly wood. Ever since, the tree has been cursed with thorny leaves to represent the crown of thorns, and red berries to represent the drops of blood spilled by Christ.

*Holly berries grow on the female plant.*

Symbolic of eternal life and hospitality, holly is today entrenched as an emblem of the Christmas season. The settlers from the British Isles brought the tradition of decorating with holly with them to our mountains.

A branch of holly with berries brought into the house brings luck for the coming year, but it should be removed before the New Year. One tradition declares that for every berry that falls before the New Year, a bit of luck will depart.

Holly is also made into wreaths; sprigs are worn in buttonholes, and, during the nineteenth century, it crowned the top of the Christmas pudding in England. Britisher Charles Mackay wrote a poem "Under the Holly Bough" that says:

Let not the useless sorrow
Pursue you night and morrow,
If e'er you hoped—hope now—
Take heart; uncloud your faces,
And join in our embraces
Under the holly bough.

In America, George Washington was a great admirer of the holly tree. He mentions it many times in his diaries. In one entry, he mentions receiving from his brother John, "a Swan, 4 wild Geese, and 2 Barrels of Holly Berries (in sand)."

Washington planted the berries in the South Semicircle of Mount Vernon, and to them he added a number of boxed holly trees he received from Colonel "Lighthorse Harry" Lee.

Naturalist writer Donald Culross Peattie deplored the fact that by the mid-twentieth century, holly bushes had been stripped and destroyed throughout much of the country near large cities because of the demand for Christmas decorations. He suggested that admirers shellack fresh holly boughs when they first purchased or collected them, so that they would be preserved. The same holly could be used year after year.

Holly can be found growing throughout this area, although the female trees that bear the brilliant berries are few and far between.

The holly's connection with the season is a living one. At Buladean Elementary School in Mitchell County, North Carolina, recently the third grade students each carried a holly twig for their Christmas program, and holly boughs continue to decorate homes.

Holly trees can even predict the weather. According to local tradition, a heavy berry crop on the holly tree means a hard winter. If you see as much red as green, you might want to get in an extra load of firewood for the holidays.

## LICHENS AND MOSSES

The Southern Appalachian Forest presents many layers of beauty. From the sky, from a mountain top, along forest trails and on your knees, you can find variety and intricate relationships that astonish and bemuse. Winter is one of the best times to investigate some of the tiny members of the forest kingdom that are hidden or overshadowed during the gentler seasons.

Some of the most intriguing and interesting of these small wonders are the mosses and lichens.

At this time of year, when all the woods wear a drab coat of gray or brown, you can find splotches of green in many shades along watercourses and spread throughout the forest floor on rocks and tree trunks. These are the lichens and mosses, small but hardy plants that never close up shop for long, but lie waiting for a bit of moisture to bring them to glowing beauty.

Lichens can be found spreading on tree trunks, branches, otherwise naked rocks, decaying wood, and soil. Fascinating

*Rock Tripe, an edible lichen, covers rock.*

eccentrics in the vegetable kingdom, lichens are composed of algae and fungi living in a stable biological equilibrium. The lichen's tough, gelatinous tissue allows it to store water even through periods of prolonged drought.

Able to absorb water vapor directly from the atmosphere, these tenacious organisms are true survivalists. Then when the rains come, the marvelous symbiotic structure may sponge up water to 35 times its dry weight.

Lichens vary in appearance and are classified accordingly. Crustose are flaky or crusty, foliose are papery or leafy, and fruticose are stalked or branching. Their colors are greenish-gray, pale gray, olive green, brown, or orange.

Foliose lichens are the most common in our area. Most folks recognize them as lichens, as they are conspicuous whether on trees or rocks. Rock Tripe is a good example. Greenish-gray on top and black underneath, this thin lichen lies flat on rocks when it is wet, but curls at the edges when dry.

Rock Tripe is edible. In Japan, certain species are gourmet items sold as "rock mushrooms." It has to be well-rinsed and well-cooked to rid it of the grit from the rocks on which it grows and the bitter taste imparted by its acids. But according to author/naturalist Ernest Thomas Seton, "It tastes a little like tapioca with a slight flavoring of licorice."

The Manna Lichen, a desert crustose lichen, is probably the miraculous food that fed the Israelites in their need. Winds and rain can tear this from the rocks where it grows, then transport it into the desert where it falls to feed desert tribes.

One fruticose species in our area that rewards a close look is the Scarlet Crested Cladonia, also known as British Soldiers and Matchsticks. The lichen sends up stalks with a bright red head, thus the common names. A good magnifying glass allows you to peer closely into the miniature kingdom of the Matchsticks. The intricate, colorful growth can be found on rocks and decaying stumps and logs.

Often found cohabiting with lichens are the mosses. Most folks recognize the small green plants with leafy stems but no

*Moss sends up spore cases at end of slender stalks.*

flowers. They grow in dense colonies, forming mats of green on rocks, fallen logs, and the ground. Springy and velvety, they invite you to rest.

A distinguishing characteristic of mosses is that the plants send up a slender stalk that holds a spore case or capsule on its upper end. Although these can be seen with the naked eye, a magnifying glass is needed to get a close look at them.

Mosses have been around for about 400 million years and have undergone little change in those many years. Over 23,000 species have been described by botanists, so they are a difficult group of plants to identify with any certainty unless you have a good field guide and lots of experience.

Yet anyone can enjoy their beauty and the intricacy of their miniature worlds by giving them a close look. During this season, almost any patch of bright green in the woods is a colony of moss. They thrive at any month of the year. While mosses may shrivel and lose their color in a drought, as soon as rain falls to renew their moisture content, they glow forth in their emerald shades.

One of the most common mosses in our area is the Hairy

Cap, a Polytrichum. This moss received its common name from the long hairs that grow from the top of the capsule to form the hairy cap that gives the name. The leaves of this moss form a bright green rosette and form dense beds.

*Moss provides a comfortable bed.*

The softness of these moss beds invites humans as well as animals to stretch out and feel the velvety comfort. Dogs will often find a moss bed for a snooze. They don't mind the dampness that sometimes results from lying in a soaked bed of moss, while humans often regret the soggy pants that come from sitting in moss.

In addition to their visual wonder, lichens and moss are important in turning bare, barren rocks into fertile communities of plants. This process is known as primary succession. Lichens begin the work by establishing themselves on bare rock. As they hold moisture and spread, they attract other lichens and moss.

As thick beds of moss build up, debris from other plants, including seeds, become trapped, forming soil that can support flowering plants, such as sedums. By stages, the once bare rock becomes the host of a thriving vegetable kingdom. This process takes much time, which is ticked off in years, not hours. But, while slow, it is sure, if left undisturbed.

On your next visit to the woods, take the time to admire the lichens and mosses. Like many humble folks, their quiet demeanor and relative obscurity hides fascinating stories.

## MOUNT MITCHELL'S WINTER ATTRACTIONS

The only time most folks hear about this highest peak east of the Mississippi in winter is when startlingly deep snow totals are cited by weather reporters. While these chilling figures tell one tale about life on Mount Mitchell during the cold months, the mountain has more to offer than frostbite and snowburn.

When warm temperatures or brilliant foliage abound, it is one of the most popular tourist spots in the South, yet relatively few people make the trip up to Mount Mitchell State Park in the winter. Nineteen ninety-six was a good year, with 33,000 visitors from November to April, less than 20 a day, according to John Sharpe, park superintendent.

Winter enthusiasts come to hike, to cross-country ski, to take photographs, or just to appreciate the spectacular views from the high peak.

"The clean air—that's the first thing that makes winter

*Roan Mountain seen through peaks along Black Mountain range from Mount Mitchell.*

special here. Views from the ridgetop are generally spectacular. The air is extremely clear. Most days in summer, visibility is ten miles, but in winter, usually, you can see 30 to 50 miles," says Sharpe, who spends his winters in his cabin in the park.

After a weather front clears the mountains in winter, the air becomes crystalline. Mountains miles away sparkle with their coats of snow. Even several days after a heavy early January snowstorm, the Great Smoky Mountains showed clearly on the southern horizon from the tower on Mount Mitchell, and nearby Roan Mountain loomed to the north just out of reach on the Tennessee border.

*David Cowart, Charlie Tolley, and Gaylord Chambers ski on an old railroad bed.*

Other easily identifiable mountains that can be seen from the tower are Grandfather to the northeast and the twin peaks of Hawksbill and Table Rock to the east. And the individual peaks of the Black Mountain range itself clearly define themselves along the ridge in the crisp air.

The clear air combines with the naked trees of the deciduous forests to reveal the shapes of the mountains and ridges. What appear to be soft, rounded mounds in the summer become sharp ridges, showing their rocky gray bones poking from the cold blanket of white in winter.

"Yes, the foliage is less. Looking down into the valleys, you can see more of the contours of the land and the valleys because leaves are off the trees," says Sharpe, standing at Steppes Gap, near the ranger station at the park's entrance.

Climbing the mountain under the naked trees allows you to see not only long distances through the forests but also across the valleys and coves to the surrounding ridges. You can orient yourself easily, if you know the countryside.

Hiking trails remain open throughout the year. The only impediment is the state of these paths that often lie buried under several feet of snow. However, even when vehicular traffic to the mountain is impossible because of icy highways, dedicated hikers find their way to the high peaks.

On a Saturday in winter 1998, when snow and ice closed the Blue Ridge Parkway access, several cars parked at the Black Mountain Campground trailhead near the foot of the mountain showed that more than a few enthusiastic spirits refused to be daunted by the season.

One intrepid group was Chris and Elizabeth Bresett, with their canine companions Puda and Bear. On a long-planned

*Hiking is fun for dogs as well as humans.*

vacation from Florida, the Bresetts decided to hike the six-and-a-half miles to the top rather than miss their view from Mount Mitchell.

On Friday, they hiked from the trailhead for four hours to reach a camping spot on Commissary Ridge. They toiled through ankle to knee-deep snow, but refused to give up. After a night's sleep to recuperate, the couple and their loyal dogs hiked the remaining way to the tower on Mount Mitchell.

"We've been planning this trip for two months," said Elizabeth, her cheeks glowing after her climb from their campground about a mile-and-a-half by trail below Mitchell's peak.

"Yeah, our Christmas present was new sleeping bags and all, and our family gave us money for gas to get here," said Chris, as he, his wife, and their dogs ate an al fresco lunch on the rocks.

"I still don't like hiking in the snow, but this is so beautiful. The stars last night were incredible," said Elizabeth, as she slipped Bear a bite.

Although only two days before the temperature on the mountain was below zero, on this morning sunny skies and a warm breeze brought 50 degree temperatures to the Black Mountains. In addition to the hikers, some cross-country skiers arrived to take advantage of the snowy yet warm conditions.

David Cowart, Gaylord Chambers, and Charlie Talley drove up on the steep, dirt South Toe Road that winds up the mountain past the Black Mountain Campground off Highway 80.

"It's pretty tough to get here when it snows. About ten years ago a couple of guys came up in a Pinto and froze to death, so they close the Parkway when it snows. It used to be a pretty popular area," said Cowart, as the group prepared their skis and readied their equipment.

"We come up here pretty prepared. There is no telling what you can get caught up in," he said, packing food and water in a backpack.

He and his friends planned to ski around an old railroad bed that still held a couple of feet of snow.

"We'll be here as long as we can. We usually go till dusk," said Gaylord Chambers, shouldering her backpack and skis to walk around the gate at the head of their skiing trail.

The group's careful preparation showed their experience with the rapidly changing weather conditions in the mountains. Superintendent Sharpe recommends that anyone planning to hike or ski be prepared for any and all weather conditions.

"The number one thing I would recommend is that you be prepared for all kinds of weather. Don't assume it will be cold and dry or cold and snowy. Be prepared for rain with weatherproof clothing and footwear.

"Dress in layers. Even on a short hike you can see the temperature change from 40 degrees to 20. There is always a risk of hypothermia," he says.

Sharpe also recommends snowshoes for extensive hiking.

"I had some guys yesterday who made a hike up around the ridge. They were exhausted by walking in the snow. This time of year, snowshoes are not a bad idea. They make a big difference," he says.

## ROAN HIGHLAND BALDS

From atop Round Bald, you can see far—far into North Carolina and Tennessee, which join along the crest of the Highlands of Roan, and far into the past, since much history traveled the same path that brings you here.

Many folks make the short but steep hike from Carver's Gap to the top of Round Bald. With easy road access and plenty of parking spaces, it is a popular site with local folks as well as tourists. A large sign erected by North Carolina's Pisgah National Forest and Tennessee's Cherokee National Forest announces the elevation at Carver's Gap—5,512 feet. The well-marked hiking trail crosses the highway at the state line.

This is one of the most traveled sections of the Appalachian Trail, as well as one of the most beautiful. Where the trail climbs from Carver's Gap, you can often see seasoned hikers with formidable backpacks and brisk paces

*From Jane Bald down to Cooktown is a long, winding way.*

sharing the path with tenderfoots of all ages who huff and puff to make it to the top.

A weathered, gray wood fence provides two ways of access. To the left, rough timbers form a ladder to carry those over who cannot make it through the narrow chute that vees right, then sharply back left to prevent vehicles or horses from making the ascent. Logs form steps to prevent erosion and to give you footholds on the steep slope. The trail passes through large clumps of rhododendron and by scattered fir and spruce trees and across the grassy meadows of the bald.

While some folks make the climb to Round Bald's summit at 5,826 feet an endurance contest, others frequently stop to catch their breaths and to admire the beautiful scenery that stretches for miles. To the south, on the horizon looms the blue mass of the Black Mountain Range, home of Mount Mitchell, the highest mountain in the East. The North Toe River Valley nestles between the Blacks and the Highlands of Roan.

The bald's meadows are mysteries in themselves, with no one sure how they began in the distant past. Their survival as balds has been threatened by the elimination of the herds of wild animals that first kept them trimmed, as far back as the days of mastadons, then the sheep, cattle, horses, and mules that fattened on the rich grasses after the demise of deer, elk, and buffalo. An experimental herd of goats worked on them early in the 1990s, but has today been replaced by human volunteers with weed-eaters in the summer.

Looking behind, across Carver's Gap, you see the Roan, which reveals itself more fully with each step of the climb. At the top of Round Bald, a small grove of spruce trees provides some shelter. Planted by Dr. D. M. Brown of East Tennessee State Teacher's College, now E.T.S.U., earlier in this century, the trees represent his attempt to understand the nature of the bald mountains.

Much battered by freezing temperatures, icy winds, and deep snows that the mountain's peak is subject to, the small grove persists. This year a number of cones show the trees' attempts to reproduce and perpetuate themselves.

The view from Round Bald's summit allows you to admire the extent of the Roan Highlands, with Grassy Ridge Bald and Yellow Mountain and Hump Mountain stretching in one direction and the Roan in the other. Yellow Mountain Gap is the traditional site of the crossing of the Overmountain Men on their march from Sycamore Shoals. They paraded on Yellow Mountain before descending into North Carolina.

Directly ahead, the trail descends to Engine Gap, then climbs to Jane Bald. Both of these landmarks have derived their names from the past. In the valley under the mountain, there are still those who know the stories, either from their own experience or from the tales of the preceding generation.

Eighty-two-year-old Essie English knows some of the stories. From her home in Glen Ayre, just down the mountain, she drove up to the Roan to work for "one day shy of 14 years." She cleaned and hauled and kept the mountain spruced up for the Pisgah National Forest.

"Now, I never heard no stories about Round Bald, just that it's the Round Bald," says Essie English, shaping the roundness of the mountain with her hands. "But Engine Gap I've heard them talk about. They pulled timber up from Tennessee and then down into North Carolina with an engine there. Cherry lumber it'd be."

Up the road in the Valley of the Roan, Marshall Ayers also remembers the engine that gave its name to Engine Gap.

"I don't know what kind of engine it was. I remember pretty well that they pulled the timber up there and then pulled it off to down here where they loaded it. I was just a little feller, eight or nine years old," says Marshall, who at 84 has seen most of the twentieth century.

According to the late C. Rex Peake, who wrote a small pamphlet about the Roan Highlands, a stationary engine was placed in the gap in 1880 to pull cherry timber up an inclined railway. He claims that the engine pulled out three million feet of wild cherry lumber.

An article in the *Tri-County News* from December 21, 1950, reported that Peake's father, H. R. Peake, sold the

stand of cherry timber from his property to S. B. Searle, who devised the plan to use a large engine with a big drum and a long cable. The cable lowered carts to the timber, then pulled them back up on a crude track made of hardwood rails fastened to crossties.

The lumber was then loaded onto wagons to be carried to the narrow gauge railroad in Roan Mountain. Furniture manufacturers used the quality cherry in their solid wood pieces that have become today's heirlooms.

From Engine Gap, a steep, narrow trail worn to the rocks leads to Jane Bald, with its story. Oral history holds an important place in the culture of the Southern Appalachians. While there are relatively few written histories of many communities in the mountains, tales passed down the generations have filled the place of books.

*Elsie Cook Yelton, granddaughter of Harriett Cook, who died shortly after being rescued from the bald.*

Sometimes, confusion can foul the transmission of the truth, especially in the details of a particular event. The story behind Jane Bald in the Roan Highlands is one of those tales that has become garbled over the years.

Elsie Yelton knows the facts, as she is the granddaughter of Harriet Cook, the woman who actually died shortly after being carried from the bald. Harriet and Jane Cook grew up down the road from Dogwood Flats, the area where Elsie lives on Cooktown Road in Mitchell County.

"Jane and Harriet were sisters. They had two sisters who lived on the Tennessee side of the mountains, and they had planned for a long time to go across the mountains to visit them. It was getting late fall. They had planned to visit earlier in the season, but Harriet had the milk sickness and had to

put it off," says Elsie.

The sisters were just two of George Cook's 21 children. Married twice, their father raised two families. Another sister, Judy, had married a Civil War veteran, Tom Ledford in 1863. Although she never had any children of her own, she held the large family together, raising several of her siblings' children, including Elsie's father, Flem.

Judy felt strong foreboding about the proposed trip and tried to talk her sisters into staying home and putting off the journey. Although Harriet seemed to have recovered from the milk sickness, Judy knew that the illness could recur under the stress of the trek over the high mountains.

But Jane and Harriet were bound to go. They yearned to see their sisters, Lannie and Madeline, in Carter County, and the delay because of the sickness only increased their wish to make the trip. Judy held the hand of Harriet's two-year-old son, Flem, who later became the father of Elsie. They watched the sisters start out happily, walking with a young relative, Sylvester Cook.

"I don't know how long they stayed. I know they wanted to visit both sisters. I'm not even sure where they lived. I think one lived in Ripshin; one lived in Roan Mountain, Tennessee. On November 16, 1870, Jane and Harriet started back. My grandmother, she couldn't hardly make it. She got weakly and faint," says Elsie, her dark blue eyes blinking behind her glasses.

The weather changed rapidly, as it is apt to do in mid-November. Blue skies gradually filled with clouds. The temperature dropped rapidly as night came on. Harriet's steps grew slower and slower as she struggled up the heights. The dizziness and nausea of milk-sickness returned.

"Harriet just made it up to Jane Bald. She collapsed under a pine tree. They had nothing to make a fire. The wind turned real cold. Jane got more and more worried, but there was nothing she could do.

"Harriet would talk and mumble. Jane didn't have any idea of the time. Then, sometime in the night, Harriet stopped talking. The frozen ground spewed up around them,"

says Elsie, evoking the fear and despair of that long night on the isolated mountain peak.

"You know Jane was scared because they was panthers and wolves in this part of the country. In 1870, this was a wild kind of place. I would have died of fright," she says, shaking her head.

With the first glow of morning, Jane's hope revived. The rising sun found her hurrying down to the valley, seeking help. She found it at the log home of Charley Young, who lived not far from Carver's Gap.

"Jane was about froze to death when she got down there. They got a wagon and put the bed—mattress and stuff—into it, and put Jane back in the wagon in that bed. They took the wagon as far up as they could go, then they had some men carry Harriet down to the wagon. She was still alive. They put her in that feather bed," says her granddaughter.

This same bitter time, far down the mountain at Dogwood Flats, Judy was beside herself. Somehow she sensed the desperate situation of her sisters.

"She was just hysterical," says Elsie.

Under her goading, the men on Dogwood Flats hitched horses to wagon and started up the road to the Roan. As they began the climb, they saw a wagon coming. It was Charley Young with Jane and Harriet.

"Just shortly after they got her here to Dogwood Flats, they got her settled and she died. Harriet was 24 years old. My Daddy had a good memory. Judy told him that his mother was 24 years old when she died. He was born in 1868, he was two years old when she died," says Elsie, the wonder of her direct link to an almost mythical past glowing in her eyes.

Harriet was buried in the cemetery near the bottom of Cooktown Road. Through the years, her headstone has vanished. Now Elsie has a general idea where her grandmother lies, but no one can point out the exact place.

Jane, who gave her name to the mountain, lived on and on.

"After that experience, the people down here started saying, 'You know—up on Jane's Bald.' She died in the 1940s.

She just lived and lived. She got so in the last years she couldn't hear thunder, she got so deaf. She could read still; her eyes stayed good," says Elsie, who knew her aunt well.

And up till the end of his life in 1964 at the age of 96, Flem Cook kept a clear memory together with his strong, upright body. So Elsie Cook knows the true story of how Jane Bald got its name.

Jane Bald's story is a melancholy one that reveals clearly how times have changed. There were no helicopters, ambulances, or emergency squads, simply the sense of duty of neighbors, men and women with only their personal strength and hardihood pitted against the pitiless elements.

Today, from Carver's Gap along a well maintained trail, the trip to Jane Bald is not an easy one, but many folks make the hike. In fact, in 1992 the trail which formerly followed the crest from the bald to the gap was moved to the North Carolina side of the mountain to prevent erosion and to allow the mountain to heal itself from the tramping of the tourist herds.

From Jane Bald looking to the Tennessee side of the mountain, you see the Burbank community, the Doe River Valley, and the smoke rising from Tennessee Eastman in the distance. Visually, the ancient landforms dominate the modern changes, but the ominous smoke speaks of the pollution that threatens the mountains today.

The hike from Carver's Gap to Jane Bald is just a bit over a mile long, but the up and down nature of the trail makes it seem longer. The time you spend on the balds can bring the past and the present into perspective. From the top you see no dotted lines separating state from state, and the very names along the trail link now with then.

# GINGERCAKE MOUNTAIN

Gingercake Mountain is only one of the intriguing peaks that make up Jonas Ridge. With its brothers, Hawksbill, Table Rock, the Chimneys, and Shortoff, Gingercake forms the eastern rim of Linville Gorge, one of the wildest spots left in the East.

While the northern end of Gingercake Mountain holds Gingercake Acres, a community of seasonal homes sprinkled with full-time residents, the main ridge is still wild. A narrow trail runs the length of the ridge, traveling through rhododendron thickets, mixed hardwoods, and pine.

The southern end of the mountain has several vantage points that provide stunning vistas of the area's most famous peaks: Grandfather Mountain, Mount Mitchell and the Black Mountain Range, Linville Mountain, Hawksbill, Table Rock, and the other peaks of Jonas Ridge. Here also stands the unusual rock outcropping that gives the mountain its name.

This upthrust rock improbably holds another large, flat

*View of Linville Gorge from Gingercake*

boulder on top. To the casual observer, it appears impossible that the cap rock can stay in place. This unique formation has had many names in the past two centuries, but its grandeur remains the same no matter what it is called: Gingercake, Devil's Cap, or Sitting Bear.

The flat rock on top reminds some folks of a cake perched on a cake stand, hence the name Gingercake. The uncanny way in which the top rock remains perched on its pedestal caused some to call it Devil's Cap. And from a distance, the rock appears to be a huge bear, sitting on the ridge admiring the scenery.

*With flat boulder improbably perched on large rock pedestal, Devil's Cap or Sitting Bear juts high above the ridge.*

Legend tells that one time two men climbed the nearly vertical sides of the lower rock, then tried to lever the top rock, or cap, off into the gorge below. While they struggled, a violent thunderstorm arose, and they were blasted from the rock by a tremendous bolt of lightning. Ever since, folks believe that if someone attempts to remove the Devil's cap from his rock, he will punish them with thunder and lightning.

Today, while no one tries to shift the cap, many enjoy the site for rock climbing. The rock challenges them, because it is more narrow at the bottom, creating an overhang climbers must surmount before they can then scale the nearly vertical sides above.

On a recent Saturday morning, Sergeant Lonzo Jeffers, two of his JROTC cadets from Avery High School, Matthew

Grindstaff and Joshua Havron, and Joshua's mother, Bobbi, hiked to the Devil's Cap to try their luck on its granite sides.

"This is the first time we've ever been to this place to climb. We found it in a climbing guidebook. We're spending the winter season doing a lot of reconning to find good sites for the warmer months," said Bobbi Havron, as she anchored the safety rope that secured Lonzo Jeffers as he attempted to get around the overhang.

*Bobbi Havron anchors rope for Lonzo Jeffers as Matthew Grindstaff and Joshua Havron watch and give advice.*

When his hands lost their grip, he swung down, supported by the rope. However, he still hit the ground fairly hard on the seat of his pants. He arose, dusting his bruised pride.

"I'm 52. Your injuries don't heal too well at 52," he said, then laughed as he stood back to find a better route to travel.

"I do this for the adrenaline rush, but more than anything else, it's a lot of fun," he said, reaching for a handhold and swinging onto the face of the rock again.

His two cadets had climbed the steep southern end of Gingercake Mountain to stand high above. The view from the precipitous end of the mountain encompasses all of the Linville Gorge from that point to the Piedmont.

The best way to get to the Devil's Cap, or Sitting Bear as government topographical maps identify it, is to turn off state Highway 181 on Gingercake Road and then take Table Rock Road to the first marked parking spot. From here, a hiking trail ascends the steep ridge, then runs along its crest. Follow

it to the right or north. At the Devil's Hole sign, the trail splits, with one section descending steeply to the bottom of the gorge.

The other branch sticks to the ridge to climb with it to jutting rocks that give a spectacular view of Linville Gorge. Then the trail leads to the base of the unusual rock formation. From there it ascends steeply to the southern end of Gingercake Mountain, with its spectacular views, before running the length of the mountain.

At the northern end, a small parking area gives access to the trail that travels along the mountain. This parking area is difficult to find, as there are no signs and it is above the many gravel roads that wind through Gingercake Acres.

During the winter season, the only colors are the blue of the sky, the deep maroon of galax plants, the evergreen leaves of Rhododendron and the needles of pine and hemlock, and the browns and greys of the naked deciduous trees and rocks.

At other seasons, the mountain glows in either the flowers of spring or summer or the brilliant leaves of fall. In spring, many wildflowers line the trail, from several varieties of trillium, to the shy trailing arbutus, to the striking dwarf crested iris. In summer, most of the rocky natural overlooks that jut from the mountain wear rhododendron flowers that provide a beautiful frame for the majestic views.

Often strong winds play across the mountain, singing in the pine needles or howling through the naked branches. A pleasant hike on a sunny day can turn into a cold ordeal when the wind brings the mist and clouds to the ridge.

The views are spectacular, but the steep sides that provide that view can be extremely dangerous. Great care should be exercised on the rim of the mountain. And while some folks enjoy camping there, nighttime is no time to be wandering around the mountain.

Gingercake Road makes a loop from Highway 181 between Pineola to Morganton on Jonas Ridge, just before the road comes to Upper Creek Falls. Table Rock Road cuts off of Gingercake Road near the lower intersection with 181.

# HAWKSBILL

Hawksbill is one of the most recognizable peaks in the Southern Appalachians. With its companion, Table Rock, it provides a landmark that can be seen for hundreds of miles along the Blue Ridge. Its name comes from the distinctive shape of its curving summit, that resembles the bill of a bird of prey. Seen from a distance, the peak looks rounded, but a closer perspective reveals the jagged rocks that jut from it.

From these rocks, you can see several of the best-known mountains; Grandfather Mountain, Roan Mountain and the chain of the Roan Highlands, Mount Mitchell and the Black Mountains, Linville Mountain, and Table Rock, the Chimneys, and Shortoff of Jonas Ridge.

Hawksbill is one of the peaks along Jonas Ridge, the steep ridge that forms the eastern side of Linville Gorge, one of the wildest of the wilderness areas in the East. From the Gorge side, the peak is inaccessible, but a hiking trail from the east side provides access to this special place.

*Hawksbill Mountain*

The Hawksbill Trail begins at a parking lot on Forest Service Road 210, which runs from Gingercake Road on North Carolina Highway 181. The half-mile trail is moderately difficult, as it travels through rhododendron thickets and forest. It climbs steadily at first, then levels off before it turns to make the ascent up the steep side of the mountain.

*Solitary hikers enjoys scenic beauty from Hawksbill.*

Good views of Brown Mountain and the piedmont appear as you ascend, with a small natural overlook to the left, just before a short, steep, rocky portion of the trail that will take you to the summit.

At its top the trail leads you to the sheltered center of the peak. Stunted, twisted pines and thick rhododendron and laurel bushes surround a cleared space where a large rock shelters a campfire ring. The smoke from hundreds of years of fires has darkened the light face of the rock.

To the left, the trail winds through the pine to a downward slanting face cluttered with large boulders. From here you can look down the Linville Gorge, with the mass of Table Rock directly before you. Jutting rocks provide a hawk's eye perspective of the steep cliffs that tower above the Linville River.

Far below, the river glints in the sunlight in two places. To the west, Linville Ridge runs on the far side of the gorge, and the majestic chain of the Black mountains closes the view.

Even in the winter, the variety of colors and textures captures the eye. Vegetation winds among the quartzite rocks, creating a patchwork. In the spring and summer, colorful

*Rocky trail climbs steeply just below summit.*

flowers, such as laurel and rhododendron and turkey beard brighten the green and grey. In the winter, the dried stalks clatter in the wind and shriveled blueberries feed the small birds that skitter off at your approach.

Narrow trails crawl over the peak to take you to various hidden nooks and crannies created by nature. Going back through the calm spot in the middle of the peak, you can follow trails to the northern end of the mountain. Here the

rocks jut upward to give you a view of the Roan and its balds to the northwest, and to the northeast, the Grandfather rules over the Blue Ridge.

The raucous croak of ravens disturbs the quiet on a calm day as the large black birds circle the peaks, and piercing cries of a pileated woodpecker rise from the trees in the gorge below. On a windy day, the rush and roar of the winds drowns all sounds as it threatens to fling you off to join the ravens in flight.

At this end, the rock reveals its genesis. Layers of quartz sand that half a billion years ago lay on the bottom of a sea crystallized into the solid masses of rock. The layers show in some sections of the rock.

Millions of years later the collision of continental plates thrust the rocks into the tall ramparts that they now form. The jagged beaks of rock provide resting places for lovers and solitary observers of the natural beauty that lies on all sides.

On a warm winter day, Hawksbill provides a pleasant spot for enjoying nature while getting some good exercise hiking. On cold, snowy days danger lurks on the exposed peak, but if you dress warmly in layers and prepare for the freezing bite of the wind, the beauty remains, augmented by the shimmer of ice and snow.

The Forest Service road provides easy access except when snow and ice coat the mountains, making the road passable only by four-wheel drive vehicles.

# TABLE ROCK

To the Cherokee, it was a sacred place, Attacoa. To the settlers, it was an unmistakable landmark, Table Rock. Today, it continues to seize the imagination of all who pass under its unique granite walls.

Table Rock's outline is familiar to anyone who has traveled the mountains of Western North Carolina. Driving to the Blue Ridge from Morganton, its unmistakable slanted top and squared sides dominate the skyline. From most mountain peaks and along the Parkway from many places, it and its neighbor, Hawksbill, create a distinctive effect—"dragon's teeth" an early traveler called them.

Its sheer rock walls rise vertically, creating sublime views and pulse-stopping ledges. Its rocky top served as an altar for Indian ceremonies over the centuries, and still today you can feel closer to the Almighty on its crest than in any church.

Overlooking the wild and scenic Linville Gorge Wilderness area, Table Rock is a favorite destination of rock climbers, day hikers, overnight campers, and sight-seers. While most areas in the gorge require a permit on weekends, Table Rock has open access.

A winding dirt road terminates a steeply climbing asphalt stretch, corkscrewing to a parking area which carries thousands each year to the trail to its top. From Jan. 1 through April 1, the asphalt section is closed, and you must walk to the trailhead.

Once there, you have a rocky hike of one mile to reach the crest. Along the trail are pines, flame azalea, laurel, rhododendron, and mixed hardwoods, as well as stark boulders and occasional striking views of ledges and outcroppings.

Deer, squirrels, and other wildlife inhabit the mountain. There are even bears, but because of heavy hunting in the area, they are extremely wary of humans. Hawks, ravens,

*Table Rock rises high above Linville Gorge.*

and vultures enjoy the updrafts created by the gorge and its mountains.

There is always something to see, but keep your eyes on the path. The trail is fairly steep and rocky, with difficult footing in places, but by taking your time and watching your step, it is negotiable by most. And the reward is great as you step with pounding heart and pumping lungs onto the top.

At the 4,099-foot summit, you find yourself above the world in a way that few mountains offer. Its abrupt upthrust provides a panoramic view from the sheer cliffs at your feet to the distant hazy horizon.

The majestic Black Mountains, venerable Grandfather Mountain, the Highlands of Roan, and other well-known

*Mitchell Joslin, 4, leads hikers to the top of Table Rock in 1994.*

ranges surround you at a distance. Nearby, the rocky walls of the Linville Gorge and the sharp sides of Hawksbill and Sitting Bear are clearly defined.

Down the gorge the spectacular Chimneys, jagged teeth of steep mountains, and the dramatic curve of Shortoff Mountain follow the twists and turns of the Linville River.

Below, the river winds its way through the spectacular bed it has carved over the millenia. You can see the water winking in the sunlight in a few open spaces through the virgin forest of the wilderness.

On the top of Table Rock are flat places to sit on and tilted boulders to climb. Small caves tempt you to explore, while the sheer cliffs entice you to the edge. A steady wind plays over the crest and sings through the sparse vegetation that

covers the summit in places.

Dress warmly in layers, for the cold on top of Table Rock on a wintry, windy day gives new meaning to the cliché "bone-chilling." Yet the cold, clear days are some of the best, for when the haze and mist have been washed from the atmosphere, you can see as far as the towers in Charlotte.

To reach Table Rock, exit the Blue Ridge Parkway to go south on North Carolina Highway 181 or go south from Pineola on that road. Look for the sign on the right to Table Rock Picnic Area, forest road 210. Go 4.9 miles to forest road 210-B, turn right and go 1.6 miles to Table Rock Picnic Area.

# VEINS OF ORE: CRANBERRY MINES ECHO THE PAST

In 1821, three brothers from Crab Orchard, Tennessee, sought refuge in the wilds of Western North Carolina to escape a warrant. During the free-for-all celebration after a community logrolling, the Perkins brothers, Joshua, Ben, and Jake, had let their frivolity get out of hand and stripped a local lad of his newly woven flax shirt and britches.

Suffering wounded pride and claiming bodily injury, the boy, Wright Moreland, swore out a warrant, but the feisty Perkins boys lit out a step ahead of the law.

To support themselves, the fugitives turned to traditional mountain occupations, hunting and herb gathering. Josh, while digging roots of the valuable ginseng plant on a hillside in what was then Burke County, discovered magnetite ore.

The brothers took their ore sample to Dugger forge on the Watauga River, about four miles above Butler, Tennessee. Assured of the quality of the magnetite, the Perkins boys

*Mine interior with ice floor and ice dripping from the ceiling.*

decided to exploit this other natural gift of the mountain.

At that time, a North Carolina statute to encourage the production of iron had been passed. Anyone discovering iron ore on vacant land could build a tilt hammer forge and, after proving in court that he had made 5,000 pounds of wrought iron, he would receive a grant of 3,000 acres of land covering his operation.

Josh, Ben, and Jake Perkins recorded their entry in Raleigh on Feb. 9, 1827. They constructed a dam halfway between Elk Park and Cranberry and established a typical forge of the day, with a water trompe, furnace, goose-nest, and hammer.

They proved their production of 5,000 pounds of wrought iron in Morganton on the fourth Monday in October 1829 and received their grant on Dec. 10, 1832.

The mine became an important resource for the South during the Civil War. Its title had passed to Jordan Hardin, who supervised about 50 men in the manufacture of iron for the Confederate government.

The ore was hammered into iron bars which were hauled once a month by a four-horse wagon to Morganton by Peter Hardin. The Confederacy used the iron to manufacture axes.

In 1882, the Cranberry Iron and Coal Co. connected the mine to Johnson City, Tennessee, by railroad. By 1900, all of the ore was smelted in Johnson City in a large blast furnace built and operated by the Cranberry Furnace Co. This process continued until 1930.

The Depression brought an end to the large scale operations of the Cranberry iron ore mines. From 1882 to 1930, the production of the mines in the Cranberry area amounted to 1,500,148 tons.

Today, the mineral rights of the mine are owned by Mike Lacey, an Avery County realtor and surveyor.

"I don't have any current intention of mining, but if tomorrow they come in and say they've found a giant quartz deposit, I might change my mind," said Lacey, whose rights cover 1,200 acres.

The mine itself sits back in a deep cove, its five mouths

*Loading conveyor frames deteriorating buildings.*

yawning widely. Thick granite columns support the openings that have been carved into the mountain. In the face of one, a small, man-sized hole enters the cavernous foyer.

In the summer, cold air exhales from the huge jaws of the mine, hinting at depths and dark places.

In the winter, ice covers several feet of water that glows greenly in the dim light admitted through the tunnels. The sounds of falling ice and rocks echo through the deep chambers, and stalactites of ice drip from the ceiling and entrances.

The main shaft goes back more than a mile into the mountain, with side shafts running off to follow the veins of ore. On the surface, breathing holes make exploration in the area dangerous.

Further back in the cove above the main shafts, a large hill is pierced and gnawed like a huge Swiss cheese. Over the years, all the surface pockets of ore have been taken by the generations of mountain workers.

Pieces of equipment litter the landscape like the bodies of large beasts. In front of the cove, the buildings of the ore

operations stand, dilapidated but still sturdy. Piles of sand testify to their post-mining use as a sand-drying facility.

Occasionally, the roar of a dirt bike disturbs the quiet, as daring riders explore the network of old roads winding into the mountain around the defunct plant and mine.

A historical marker on the nearby highway tells of the past glory of the mine, but "no trespassing signs" warn those who might want a closer look to stay away. Falling rocks and deep holes make exploring the area extremely dangerous. Lacey is considering fencing off the area because of trespassers.

For now, the mountains shelter the remaining veins of ore, wealth waiting for future generations with improved technology.

From the mines come echoes of the past only.

*Abandoned machinery rusts near mine.*

# WINTER PASTURE

The grays, browns, and tans of winter seem a greatly diminished echo of the startling colors of fall which precede them. Yet, if you look closely at the bare trees and drab fields, you will see that they have their own power.

As the morning mists rise or the evening light strikes gold before sinking behind the hills, winter scenes capture your eyes. In the bright light of day, the individual plants catch your attention, showing that even in death they can bring delight.

Long after the showy loveliness of their blossoms have faded, the plants of pasture and open field present a muted beauty that lingers as long as the stalks and husks stand. Only when a heavy snow has crushed them to the ground, where they decay to feed the next generations, do they lose their intricate shapes.

The showy pink of the bull thistle disappears with freezing temperatures, but the distinctive sharp spikes that make this plant one that you handle only with thick gloves persist into winter. If you look closely, you will be amazed by the sheer number of the spikes and their comprehensive placement. The stalk wears a spiny defense as do the pods left after the blossom fades.

The winged seeds in these pods help to spread the pasture pest, but the Cherokees found the thistle-down to be perfect for making the wadding that they wound around the darts they used in their blowguns.

Another pasture

*Thistles bristle with sharp points.*

*Bright orange fruit of horse nettle.*

plant that develops pods filled with seeds attached to silky down is milkweed. An important food source for Monarch butterflies, the dispersal of the seeds helps to ensure future generations of the fragile flier.

In summer, the plant wears several large clusters of pinkish-purple flowers which turn to rough green pods. As fall passes, the thick skin of the pods thins as it turns to a light tan color. They then split open on one side to release the many seeds with their individual tufts of silky hair that catch the wind to disperse.

In winter, the stalks hold the dried, opened pods that have a slight orange tint inside. Often a rattling shell will harbor a seed or two that didn't leave. Occasionally you will find an unopened pod, filled with many overlapping seeds carefully tucked in with their parachute tufts ready to seize the wind.

Other summer-bright plants remain recognizable without their showy blossoms. The dried remnants of Queen Anne's Lace blossoms curl up and inward, forming an intricate cup-shaped bird's nest. The bright blue blossoms of chicory turn into tight clusters of tan petals that small birds

*Split milkweed pod spills tufted seeds.*

investigate for the seeds left behind.

The bright yellow pyramids of tall goldenrod blossoms keep their shape after their color goes, leaving behind fluffy white clusters that are as attractive as the more showy blossoms. The flat umbrellas of small yellow flowers of the stiff goldenrod become miniature candclabra.

Even the grasses take on quite different appearances in the winter. The deep green of corn grass turns to a golden tan, and the plants look like miniature cornstalks. Standing stiff and tall until crushed by heavy snows, corn grass is a favorite of livestock looking for something to nibble in the winter pasture. It also lures deer down from the woods for a bite.

Stretching high above the soil of the fields are the dried remnants of the Joe-Pye weed. The once colorful blossoms have dried to a rich golden tan that the hollow stems continue to support as much as eight feet above the ground.

While most of the brilliance of summer and fall is muted, some winter plants maintain their colors. The wild strawberry's leaves share the color of the plant's fruit, varying from reddish to a deep burgundy tint. Some of the leaves remain

green with a burgundy border. Similarly, simple plantain leaves take on a bright purplish-red hue, standing out brightly from the drab background of the field's floor.

Even more outstanding are the bright fruit of the horse nettle plant. This member of the nightshade family grows yellow, tomato-looking fruit after its pale flowers fade. While the plant is quite attractive in summer with its blossoms and in winter with its glowing fruit, sharp stickers make many consider it a nuisance.

Sharing the stigma of stickers are the various briars—blackberry, black raspberry, and red raspberry. The briar stems retain their sharp protection all year, and in the winter their brightly colored stems stand out clearly when they are in large patches. Reddish to neon purple, raspberry whips glow in the cool winter sunlight.

Briar patches are famous for sheltering Br'er Rabbit, and his mountain kin find them handy hiding places, too. Even chickens will seek shelter in the cozy confines of a briar patch where they can scratch for a bit without worry of becoming food for a hungry hawk patrolling the winter stripped field.

While a close look at the pasture will reveal the variety of winter beauty, a scenic perspective also discloses that the season has its own natural wonder. Surrounded by the stripped trees which show their shapely structures more clearly than when they wear their thick summer dress of leaves, ornamented with the gray, weathered wood of an old barn or the rich rust of a tin roof, set off by the different shades of tan, brown, and gray, the fields become "as pretty as a picture."

And to appreciate this natural composition, you need spend only time and attention.

# WINTER WAYS

Since Old Man Winter has finally found his way into the mountains, life in the high valleys has adapted to his icy presence. Livestock, domestic animals, and their masters must dance to Winter's tune, adjusting to his difficult challenges as well as enjoying his opportunities for fun.

Horses and cattle for most of this season had found life comparatively easy. Mild temperatures and sunny days kept a hint of green in pastures, giving them something to browse upon as they meandered about. But when the single digit temperatures and several inches of snow blew in, the easy life ended.

Willie Street had to move his cattle down from icy Greasy Creek to the bottom land under the Roan, where they could be tended more easily. Alternating layers of ice and snow made travel up the road difficult and dangerous, and the cattle needed to be fed and checked whether the sun shone or the blast blew.

*Horses eat steadily to maintain their body temperatures.*

*Calico and Midnight look over the snowy landscape.*

Horses that were getting along well on a little hay and feed while they spent their days and nights munching across pastureland that still produced, suddenly began to demand double and triple helpings of hay when a foot of snow covered their pasture. While furry coats keep them comfortable in all but the bitterest weather, they need to eat steadily to maintain their body temperatures.

The cliché "eats like a horse" must have been coined by a farmer who watched his haystacks disappear on wintry days. My horses, a young Belgian mare, a Halflinger gelding, a paint mare, a thoroughbred mare, and a feisty, old, white pony devour a bale of hay in less than an hour, then stare at the house waiting for their feeders to appear again.

As long as they get a quart or so of feed each and plenty of hay, they enjoy the snowy weather, sheltering in the barn only when the wind rises to a howl and the temperature drops below ten degrees. Then they keep their heads in the hay mangers, steadily chomping to wile away the tedious hours.

Most days the horses break through the ice on the pond for water, but when the temperatures drop and thicken the

*Mitchell and dog Frodo enjoy a day on the slopes.*

ice, my pastures have springs that remain open for them to drink from; other folks have to get out with fresh water by the gallon.

Chickens in the coops always need to receive water, and they prefer it warm when the cold arrives, so we carry hot water to the coop. Unlike the horses, who cavort around the fields in the snow, chickens hate to put their toes into freezing snow. When the sun lures a hen or rooster out, usually the chicken looks for a pole to perch on, or jumps right back into the coop.

Dogs and cats have their individual preferences for negotiating snowy stretches. My cat Calico prefers traveling along fences or rocks rather then immersing herself in the ice and snow, but Midnight, a tomcat, is just as happy plowing through the drifts. Both cats enjoy the small birds that are attracted to the shelter of buildings and thickets during snowstorms, although usually the feathered creatures are much faster than the house-fed cats.

Most dogs enjoy the snow; however, the longer the fur, the happier the dog is in the cold. My hounds get excited by the rabbit tracks indented in the glistening surface, but prefer curling up in front of the stove. Our long-haired mongrel Frodo has to be lured into the woodshed, for he prefers the freedom of dashing through the drifts. He'll nearly disappear as he sticks his nose deep into the snow to sniff out a field mouse or chipmunk hidden under the surface.

When the hounds are scorching their fur as they cozy up

to the heating stove, Frodo is outside rolling in the snow, playing with his collection of bones. He also enjoys sledding with the boys, chasing them and jumping on for a ride.

One of the most pleasurable aspects of the snow is the opportunity it provides for putting gravity and the slick surfaces to work. Trails through the pasture become sled runs that can be ridden for hundreds of yards when conditions are right. Of course, there is always the danger of sliding into a briar patch or crashing into a boulder, but such are the hazards of youth.

My son Mitchell separated his shoulder the day after Christmas as he tried out his new sled in the snow. He hit a rock at top speed and flew about ten feet in the air before crashing down. As soon as he got the brace off this past week, he was out again, saying, "But I've learned how to steer now!" Except for some scrapes, this time he and his brother, Dylan, emerged intact from their days on the slopes. The deeper the snow, the safer the rides.

For adults, the visual beauty of the valleys and mountains is a more settled pleasure delivered by Old Man Winter. Given a new blanket of white, mountainscapes assume a fresh beauty. The grays and brown that usually turn the vistas into uniform drab transform against the snow. Fence lines, trees, and trails define boundaries clearly, the forest shows each individual trunk, and weathered barns become architectural masterpieces. Combined, the various pieces create natural pen-and-ink sketches that only need a frame to become works of art.

The rigors and the beauties of each of the four seasons have helped define the culture of the Southern Appalachians. The place and the people would not be the same without the sure cycle of the seasons. Winter is here whether we approve or not, and we will play by the Old Man's rules.

## LADYBUGS

Ladybugs are everybody's favorite insect—usually. Their bright orange-red color and sporty black dots bring a smile to everyone's face—usually. Their voracious appetite for destructive aphids cheers plant lovers—usually.

However, while a couple or three or four ladybugs are cute, two or three or four hundred of them can be too much of a good thing for some folks, as many Mitchell Countians discovered in 1999.

For some reason that has yet to be positively identified, from fall 1998 into the following winter, ladybugs survived in large numbers, filling homes with their frantic flying and covering walls and windows with the bright colors. Students at Buladean Elementary School began a project to monitor the colorful critters and to research the bugs to learn about them.

Teacher Patsy Hughes initiated the ladybug learning.

"I got the idea looking at my window at home. Last year I'd have less than five crawling around. When I would find a ladybug (I'm an insect person; I love science), I'd say, 'Look how pretty it is,' and I'd put it on a house plant.

"This year, I've had as many as 103 on one day. My student Morgan Elliott had over 400 in her house one day," she said, watching as her classroom buzzed with insect research activity.

Some students studied the

*Lady bug attacks aphids.*

*Buladean students enjoy lady bug studies.*

small creatures through microscopes. Others used the internet to gather facts, statistics, information, and explanations. Some worked on poems about the little beetles, others put together research papers documenting their study. Still others charted the numbers they counted against the temperatures of the day of the count.

"I get over two hundred every evening, sometimes more. If it's warm, they start swarming on the south side of the house," said student James Benson.

A large bulletin board held some of the results of the students' work—graphs and poems and essays concerning the ubiquitous ladybugs. "They remind me of an army tank," one poem said.

"Help! Ladybugs have invaded my house," said one essay.

"As I sit and noticed that ladybugs are red, I just wonder if they are orange instead. Do you ever wonder how many spots they have? But I think they are beautiful instead," said Ashley Phillips' poem.

Ashley walked around the classroom with her baggy of ladybugs, offering them to the researchers at the microscope as she discussed their various shades of orange and red.

Hers was an aesthetic appreciation.

Eighth-graders Kimberly Hughes and Gail Grindstaff delved more deeply into the story of the insects. They researched on the internet and interviewed local experts.

"We called pest control places around the county. Goforth Pest Control said they were getting eight to ten calls a week about ladybugs. They told us just to let them run their course till they left on their own. They said that they were beneficial to our environment," said Kimberly Hughes, wearing a bright red shirt and a big smile.

Her classmate Gail Graindstaff said: "I called a dude from the agricultural extension office. I met with him today, and he gave me a lot of information on ladybugs. He just told me there wasn't anything to do to get rid of them. The state won't let you exterminate them because they are useful for the environment.

"He said one lady from Red Hill called angry and wanted to know who to sue for bringing them in. His name is Jeff Vance, and he's coming to school to talk to science and math classes."

Their teacher Patsy Hughes said the question of where they came from interests everyone. The largest number of the ladybugs appeared to be the multicolored Asian lady beetle, a native of Asia. The USDA has released these bugs in parts of the Southeast, and the beetles have also come in on ships. In addition, local farmers have released the bugs for crop protection.

"They could have come in on Christmas trees. We did a workshop two summers ago up at Wayne Ayers'. Ladybugs were brought in to eat the aphids off his Fraser firs," said Patsy Hughes, in her bright orange-red sweater.

Wherever they come from, the bright bugs had the attention of everyone in the community. Bringing a living issue into the classroom sparked enthusiasm and an appreciation for research and the scientific method. The ladybug can be beneficial in more than one way.

# HOT SPRINGS

For over 200 years, the hot mineral springs at this resort town on the French Broad River have hosted folks needing relief from a variety of ills, and for far longer the native Americans visited them as they wandered through the rich river valley.

Early this century fire and flood devastated the resort, but today a renaissance at the watering spot has people soaking their cares away once again. In 1990, Eugene Hicks returned to his roots in the small town to revitalize the spa, and he and his wife, Anne, are slowly but surely rebuilding the fame of this Southern Appalachian treasure.

"Every year it builds more and more. Word of mouth and TV and newspaper articles bring most of our new customers. We have been busier this winter than before at this time of the year. Today we are booked straight through to midnight," says Anne Hicks, sitting by the blazing bonfire that warms waiting bathers this Valentine's day.

The night before, bathers kept the staff busy until

*Advertisement for Hot Springs Hotel in 1883.*

1:30 in the morning. More and more folks are discovering the romance of a moonlit bath in a jacuzzi filled with the naturally hot and healthful mineral waters that well up from 6,000 feet underground through cracks in the limestone that underlies the village.

"Last year we had 30,000 to visit the springs from all over the country and around the world. It seems that people from Europe and the Orient traditionally go to hot springs. Their health insurance even pays for them to go to springs," says Eugene Hicks, joining Anne beside the roaring fire.

The February morning began cold, but with the sun peeping through the clouds, the valley warms quickly. Forty miles away, it is snowing on Roan Mountain. Here, people relax in the hot tubs, steaming their troubles away.

Some of the tubs are protected from the elements by plastic tents that seal in the steam and keep out the rain and snow. Others can be left open to the weather. The French Broad flows by just ten feet away from some of the tubs. Mallard ducks preen themselves on the shore line as they watch the coming and going of the human water seekers.

This coming and going goes back a long way. No one knows when the Indians first discovered the springs, but their presence is proven by the large number of artifacts from Native American culture that turn up. The Hickses harvest as many arrowheads and pottery shards from their garden as they do tomatoes.

The first records of white discovery of the area refer to two men looking for lost horses who noticed the warm, effervescent waters in 1778. Within a year, pilgrimages to the healing waters, known as Warm Springs then, had begun. John Strother, whose crew ran the line between Tennessee and North Carolina in 1799, wrote on June 28 that after a hard day of surveying near Paint Rock, "We then went up to Warm Springs where we spent the evening in conviviality and friendship."

The next day he wrote, "The Company set out for home to which place I wish them a safe arrival and happy reception, as for myself I stay at the Springs to get clear of the fatigues

of the Tour."

In the early 1800s, Bishop Asbury, the Methodist missionary who traveled throughout the mountains holding services for the isolated settlers, frequently stayed at Warm Springs as a respite from his arduous journeys.

In 1848, a northern travel writer, Charles Lanman, visited the springs on one of his jaunts. He described the resort and its patrons:

"The Warm Springs are annually visited by a large number of fashionable and sickly people from all the Southern states, and the proprietor has comfortable accommodations for two hundred and fifty persons. His principal building is of brick, and the ballroom is 230 feet long."

Lanman then listed the diversions provided, "Music, dancing, flirting, wine-drinking, riding, bathing, fishing, scenery-hunting, bowling, and reading, are all practiced here to an unlimited extent," as well as describing an exciting deer-hunting episode.

In 1885, Charles Dudley Warner, a novelist and collaborator with Mark Twain, described life at the springs in *The Atlantic Monthly* in his series of articles, *Travels on Horseback*:

*Hot Springs is located on the French Broad River deep in the mountains.*

*Historic marker and spa sign welcome guests.*

"The main house is of brick, with verandas and galleries all round, and a colonnade of thirteen huge brick and stucco columns, in honor of the thirteen States, a relic of post-Revolutionary times, when the house was the resort of Southern fashion and romance. . . .

"The house is extended in a long wooden edifice, with galleries and outside stairs, the whole front being nearly seven hundred feet long. In a rear building is a vast, barrack-like dining-room, with a noble ballroom above, for dancing is the important occupation of visitors."

Warner liked the informality of the place, finding "a sense of abundance in the sight of fowls tiptoeing about the verandas," and feeling that "to meet a chicken in the parlor was a sort of guarantee that we should meet him later on in the dining-room."

During World War I, the resort became an internment center for German sailors and their families, but in 1920 the hotel burned down, and the springs subsided into insignificance, until the Hickses arrived to bring life back to Hot Springs.

They started with one jacuzzi, then added a second, then a third, until now there are eight available for visitors. And

these are just the beginning.

"We're going to put a world-class spa up there on the knoll," says Eugene, pointing to the rise above the floodplain where the jacuzzis now sit. "We're in the process of getting the drawings completed. A hotel is in the plans."

The hot springs are the natural attraction that keeps people returning. According to Eugene, three-fourths of their customers return, and many make regular visits to the spa.

"We have people that drive up from Atlanta in the mornings to bathe in the springs, then drive back home," he says, then laughs, adding, "You just can't imagine how people love it."

"In the summer people with kids get off the road ready to bite each other's heads off. After being in the pools for a few minutes, they're all playing like kids. Everyone has a good time. It's relaxing, it's different, it's fun," he says.

In addition to the present baths, the Hickses offer therapeutic massages by certified therapists.

"A soak in the spring then a massage go together," he says.

In addition to the baths and the massage therapy, the Hickses offer camping, with everything from primitive campsites to full-service R.V. hook-ups and cabins. They have also just opened a golf driving range.

The Hot Springs Spa and Campground is open seven days a week. For information and reservations, call 800-462-0933.

"Especially weekends, until we get our expansion finished, it's best to call ahead. We've had several disappointed people who drove up when we didn't have an opening," says Eugene.

To reach Hot Springs, from Sam's Gap take Highway 19-23 to the Mars Hill exit, go to Highway 25-70 and follow the signs. From Newport, Tennessee, it is 26 miles on Highway 70.

# PAINTERS

The eastern cougar has been a part of mountain lore from long before the advent of the white man. Known throughout Southern Appalachia as the painter, this large tawny cat remains an enigma and a talisman of the power of nature.

Today this shadowy feline figure continues to haunt our imagination. Lurking on the fringes of sight and consciousness, the eastern cougar, considered extirpated by most wildlife officials, then declared endangered and protected by the 1973 Endangered Species Act, refuses to die.

Sightings and the resulting stories flourish throughout the Appalachian Mountains and beyond. Southward into Florida and northward into Canada, the elusive cat prowls up and down the Eastern United States.

Captivated and puzzled by the shadowy figure, two Lees-McRae College biology professors have begun a study to sort myth from reality in the story of the mountain lion in this area. Gene Spears and Stewart Skeate have posted signs

*Cougars are a majestic part of Appalachian heritage.*

throughout Northeast Tennessee, Northwestern North Carolina and Southwest Virginia asking for sightings of cougars to be reported to them.

"The history is that over the past few years we have heard a number of anecdotal stories of mountain lion sightings in this area. We want to start keeping records of the sightings," says Stewart Skeate, who lives on the backside of Beech Mountain.

Skeate and Spears are mapping the sightings to see if clusters validate the stories unsupported by photographs or physical evidence.

"A lot of people are skeptical about sightings from the general public. Clustering will lend support to such sightings," says Gene Spears, who lives between Banner Elk and Valle Crucis.

Both Spears and Skeate have neighbors who have reported seeing the big cats recently. This coincidence piqued their curiosity and led to the study they have initiated.

"My next door neighbor was driving up to his house on Ed Perry Lane late one evening. A large cat jumped out in front of his headlights. It just stood there for a second.

"He saw its tail real clearly. It was a long tail—that is important. Then it jumped away, in one bound it disappeared," says Spears, indicating that the long tail distinguishes the cougar from its feline relative the bobcat, a known denizen of the Southern Appalachians.

Skeate's neighbor reported seeing a large cat in an open field on the Watauga County side of Beech Mountain.

"It was evening, still good light. He saw a mountain lion walking across his field. He saw it clearly," says Skeate, who has involved students in his mammalogy class in the study.

One student has reported that his mother saw a mother cougar with her kitten.

"She had seen a big cat around the Vilas area where she lives. Then one day there was a baby cat in her driveway. She was afraid to approach it because she didn't know where the mother was.

"Then she heard the mother calling it, and it walked into

the woods. She had seen the adult clearly during the day, walking up her driveway," says Skeate.

While most of the stories the biologists have heard are anecdotal, there has been a cougar sighting confirmed by officials of the Virginia Department of Game and Inland Fisheries, according to an Associated Press report. Two department employees saw a cougar near Hazel Mountain in southwest Virginia on the border of Russell and Dickenson Counties.

The cougar had been raiding Luther Chaffin's goat herd for several months in late 1996 and early 1997, when a neighbor reported seeing a cougar cross a road, carrying a goat in its mouth. When a U.S. Department of Agriculture biologist examined the retrieved corpse of the goat, he found the broken neck and deep bite marks consistent with wounds inflicted by cougars.

An interesting aspect of the painter question is that many of the reported sightings specify a black cat. According to Spears, there is no record of such black panthers ever having been captured or shot in the history of the United States.

"They are not known to exist between here and Tierra del Fuego in South America," he says, referring to the southern tip of the continent.

A wildlife expert from New York, Peter O'Shea, who is the conservation chair of the St.Lawrence/Adirondack Chapter of the National Audobon Society, believes that the cougar population in the East does include a number of these black panthers.

"There's a possibility in the East of a genetic bottleneck. I and many others feel that the eastern cougar did in fact almost, but not quite, become extirpated.

"There was such a low number of cougars that certain genes were lost and other genes were fixed in the population, and as the population rebounds we could be seeing the strong emergence of a strain of black animals as the product of this," says O'Shea in an article in *Outdoor Life* in December 1996.

Wildlife officials in the past have been reluctant to admit

*Stewart Skeate and Gene Spears with the sign they have distributed.*

that the eastern cougar survives, for if it does, its place on the endangered species list alters management possibilities for the U.S Forest Service and other government organizations.

In the recent past, sightings of mountain lions in the Southern Appalachians led some conservationists to consider filing a lawsuit over clearcutting in national forests, according to an article in *American Forests*.

The question of whether sightings are of eastern cougars as a species or of escaped or released cougars from elsewhere has not yet been answered. There is a possibility that mountain lions from the West were deliberately introduced into the area.

"From some of the people we have been talking to, we have heard that there is a rumor that about 20 years ago someone brought in western cougars and deliberately released them," says Spears.

"We are trying to get more information about this to find out if it really happened, so if anyone knows anything about such a thing, we would like them to call us," he says.

A brush with a cougar in the wild is a vivid experience, not easily dismissed. This is why so many tales of painters persist in Southern Appalachia.

I have my cougar story, too.

On a cold November night in 1985, after supper I went for a walk with my three hounds on Greasy Creek. We walked up into the pasture across from the old Moseley house and climbed to the top of a small knoll. Only one star shone through the clouds. Light glowed dimly from the clouds and the piles of snow heaped in coves and sheltered places.

As I stood on the knoll enjoying the cold beauty of the night, a piercing scream came from the ridge across from me. The hair rose on the back of my neck. I thought a woman was in deadly distress. The scream came again, shattering the night. I began to run to see what was wrong, when my dogs came running to me, whining and clustering around my legs.

Suddenly I realized that a cat had made the noise. At first I thought it might be a bobcat, but then I realized that it must be a panther, the legendary painter of the mountains, calling from the cold hills. I had always heard its call described as a woman's scream.

Echoing far in the distance I heard an answering cry.

The next morning I climbed to the top of the ridge. There I found large cat prints, about four inches in diameter. There was no other sign.

If you have such a story or have seen a wild cougar in this area, the two professors request that you call them at Lees-McRae College to give them specific information about the time and place of the sighting. Call Skeate at (828) 898-8787 or Spears at (828) 898-8744.

# TOE RIVER

Sparkling running waters for millions of years have coursed through the Southern Appalachians. They have shaped the ranges and carved the gorges that we wonder at today. Indians built their villages near the creeks and rivers, and white men greedily grabbed the rich bottomlands deposited by the clear rush of water.

*The South Toe River begins in these rushing waters high in the mountains.*

The river that drains the highest valley of the Southern Appalachians still carries the name that native Americans gave it before the appearance of white settlers. The name has been shortened, but the legend behind it is still well known.

The Estatoe River has become the Toe, giving its name to the Toe River Valley that lies beneath Grandfather Mountain, The Roan Highlands, and the Black Mountains, home of Mount Mitchell, the highest peak east of the Mississippi. The North Carolina counties of Avery, Mitchell, and Yancey lie in this natural basin created by the swift cold waters of the Estatoe.

The name memorializes a tragic love story, a tale of a Native American Juliet and her Romeo, young lovers from rival tribes whose lives were sacrificed to the enmity that tried to keep them apart. While various versions of the legend have survived the destruction of the civilization that created them, the flowing river is the only tangible trace of the lovers.

The beautiful Estatoe matured in her sixteenth year as the most lovely and accomplished daughter of her tribe. Her aging father, the chief, doted on his child, the flower of the valley who had absorbed the lore of her people and had grown as a part of the natural beauty that surrounded her.

She loved and knew the animals, the trees, the flowers, and the running waters of her homeland. She could imitate the whistle of the redbird and the undulating flute tones of the veery. She adorned herself with the flaming flowers of the azalea and the white rhododendron blossoms that flourished near the creeks under the high canopy of the forest.

She swam and bathed in the emerald pools of the river. She lived happily in her mountain home, flowing through the seasons with their unchanging patterns of the wheel of life.

Her father recognized that she had reached the season of womanhood and selected from his warriors an older brave who had distinguished himself in both war and peace.

As lovely young women will, Estatoe had already found for herself the love of her life, a handsome brave of a rival tribe.

They would meet in a secluded clearing near the river to share their hopes and fears for their future.

When the chief's chosen suitor presented Estatoe with a rich robe to declare his intentions, she willfully rebelled, telling her father that she would not join herself to the older man she did not love. The more forceful her refusals became, the angrier her father grew. He ordered her to remain in the village and prepare herself for the betrothal ceremony.

That night Estatoe slipped from her home, which had become a prison, under cover of darkness and fled through the forest to meet her young love in their secret spot by the river. When she told him of her father's plans and her love and fears, the two decided to flee to find freedom and life elsewhere.

Whether they followed the banks of the river or silently slid through its clear waters in a canoe is uncertain. What is known is that her father and his warriors followed fast, and the lovers found union in death beneath the shimmering surface of the river rather than be separated.

To honor her and her courage, the tribe gave her name to the racing flow where she had played in life and where she found a road to the afterlife. Although today the Estatoe is popularly known as the Toe, her name is preserved in its full name and in the Mitchell County community of Estatoe that lies between the North Toe and the South Toe.

These two branches join to form the Toe, which is the border between Yancey and Mitchell Counties for several miles. Then where the Cane River enters the main flow, the Toe becomes the wild Nolichucky as it dashes through a deep gorge into Tennessee.

The South Toe rises at the crest of the Blue Ridge near the Black Mountain Chain. Rain falling to the east of the Parkway finds its way into the Atlantic Ocean; that which falls just a few feet away travels through the Toe to the Nolichucky to the French Broad to the Tennessee to the Mississippi to the Gulf of Mexico.

You can follow the growth of the South Toe from its first drips and trickles to its broad emerald green sheet. National

Forest Road 472 runs from the Blue Ridge Parkway down to the Black Mountain Campground, then on to Highway 80. It crosses the infant South Toe several times, and runs beside it for much of its length.

The heavy forest cover filters the drops of rain or melting snow into tiny rivulets that join to form narrow branches that run into the gradually growing river that races down the steep slopes beneath large hemlock trees and hardwoods.

*Swinging bridge crosses the Toe at Lunday.*

At the Black Mountain Campground, fly fishermen gather to try their luck on the native speckled trout that thrive in the clean, clear water. Highway 80 then follows the course of the South Toe until it joins its sister flow near the small community of Kona.

In 1987, the South Toe became the first river in the state to receive the designation, Outstanding Resource Waters. The state Environmental Management Commission so designated the river to recognize its pristine quality and to require a public hearing before a permit could be issued allowing liquid from a wastewater treatment facility to be discharged into the river from its source to U.S. highway 19-E at Micaville.

"The designation gives the river a higher level of protection. I would like to think that the river is not standing still but continually improving since then," said Max Haner of the

North Carolina Department of Environment, Health, and Natural Resources office in Asheville recently.

In addition to the restrictions on wastewater discharge, Haner cited improvements in controlling runoff from feldspar and other mining operations as contributing to the quality of the river. He believes that the surrounding community has developed an increasing awareness of the importance of protecting the water resources of the area.

The Toe River is important not only as a natural resource but also as an important part of mountain historical heritage. There was a time earlier in this century when it was little respected and highly polluted. The river's story tells much about the past and the present in our Southern Appalachians.

Over many millennia, the Toe River has carved the valley that bears its name. Its clear, green waters cooled the lips of herds of ancient beasts, from the mastodons to the elk and buffalo that have disappeared forever from their homeland. More than a mere resource, it has shaped the land and served both beasts and mankind in its inexorable flow to the sea far to the southwest. Yet the lack of foresight of recent generations has threatened its productive life for several decades.

Silt, sewage, and refuse choked it nearly to death.

"When I was a kid, the river was so muddy you could almost walk across it, particularly the North Toe. It was yellow-gold in color," says Ted Ledford, who grew up on White Oak Creek, a tributary of the Cane Creek which joins the Toe River at Toecane.

Robert Lee Byrd agrees. He's lived on the Toe River at Forbes since the 1930s and has seen the ebb and flow of pollution.

"It was clean back then, back when I was a boy. There wasn't no mining or anything. We used to fish back when I first moved here," says Byrd, who moved from nearby Red Hill as a teenager and has spent the rest of his 76 years in his frame house overlooking the river.

"All my life it's just been the Toe River, it's all I know. But

this old clay mining for awhile kept it dirty for years. It still gets muddy when rain breaks over the [containment] ponds at the mines.

"That's when the mud comes down still, when it comes a big rain," he says, looking over the railroad tracks that run through his front yard between his house and the river.

Regulations on mining discharge and efforts to reduce non-point pollution from farms has gone a long way in the past decade towards restoring the Toe River system to its former state.

"There's been a lot of progress in Mitchell County with the feldspar and other mining operations," says Max Haner of the North Carolina Department of Environment, Health, and Natural Resources Office in Asheville.

Nature began the river cleanup in 1977 by sending a prodigious flood that swept the deep layers of mud, silt, and pollution from the river's bed, scouring clean the shoals and holes with turbulence.

The surrounding high mountains sent a biblical amount of water streaming from their sides, a disguised blessing.

"The flood was November 30, 1977. That underpass was about two-thirds full," says Robert Lee Byrd, pointing to the railroad underpass that leads to his house.

The 15-foot tall, arched tunnel is many feet above the river's level as it rolls serenely by this bright December morning.

"The river hasn't changed much in my lifetime. Ain't much place for it to change. It just runs through this gorge about as it always has," says Byrd, warming himself in the strong rays of the sun that warm his porch, protected from wind by the deep walls of the gorge.

Also protected in the gorge today is the Appalachian elktoe mussel that has been recently added to the endangered species list by the U. S. Fish and Wildlife Service under the endangered species act of 1973. The mussel exists only in the Toe River, the Cane River, the Nolichucky River, and the Little Tennessee River, after being eliminated from its other habitats by deteriorating water quality.

The Cane River joins the Toe river near Poplar, North Carolina, then the Toe becomes the Nolichucky River, which eventually runs into the Little Tennessee.

"The mussels that are still there are doing okay, but we haven't seen any signs of successful reproduction in the Toe River drainage at all," says Cheryl Bryan, fisheries technician at the Toecane District of the Pisgah National Forest.

According to Bryan, there is a host relationship between the Appalachian Elktoe mussel and a certain fish species that is important to reproduction of the mussels, but more research needs to be done to identify the particular fish species to see how it is faring in the river system. The water quality is important.

"It is improving. I'm sure there are spots where there are discharges where the water quality is not what we want it to be. But it is much better than it has been in the past," says Bryan.

As part of the U. S. Department of Agriculture, the Forest Service supports the naming of the Nolichucky River a national Wild and Scenic River from the Poplar Community to Mine Branch in Tennessee.

"This legislative action is recommended to preserve the free-flowing nature and outstanding scenic and geologic values of the Nolichucky Gorge," wrote Secretary of Agriculture Mike Espy in a letter to congress in 1994.

U. S. Representative Cass Ballenger, through his press secretary, recently indicated that he is interested in pursuing the matter.

While the Wild and Scenic designation would not affect fishing or other recreational uses of the river since state fishing laws would continue to apply, it would prohibit the river from being dammed, diverted, or altered in any way that would affect its "free-flowing nature."

Although the bill refers to the Nolichucky River, according to area residents that should read "Toe River" up to the state line.

"Down at the state line—where it goes over the state line, then it's known as the Nolichucky. Down through the gorge,

its the Toe River," says Phin Peterson, who has run the Phin Peterson General Store since 1956.

Other area residents who sun themselves on the bench in front of Peterson's store agree; it's the Toe all the way to the state line. Hunters in their orange caps predominate on warm December days, but fishermen often stop here for supplies during the fishing season. In addition to locals, many come from off the mountain to try their luck in the river.

"There's a lot of people from off goes down in those old boats afishing," says Peterson, nodding towards the sparkling waters of the Toe, which flow through three mountain counties.

The North Toe River begins many miles away, up in Avery County, past Newland as a small branch. It flows through that county seat, then makes its way through Plumtree, Ingalls, Spruce Pine, and Penland, constantly growing before it joins the South Toe at Kona, where the Toe then forms the border between Mitchell and Yancey Counties.

The river is the knife that has shaped this high mountain valley. It has blessed the land with clean, potable water for most of its existence, until the short sight of modern man turned it into a drain for his refuse.

Dumps still appear along its banks, with abandoned appliances, rotting dead animals, and bags of household garbage, but these are the exception rather than the rule now.

Today there is hope for its return to a pristine condition. But the people who live along its banks and along the sides of its tributaries must take responsibility to ensure the sparkling waters flow free of garbage, sewage, chemicals, and silt all the way from high mountain springs to the broad river.

# MAPLE SUGAR

Many mountain folks practice the old ways that form their heritage; however, sometimes it is the newcomers who revive traditional techniques of mountain living. High on Fork Mountain, a ridge running from the Roan in Mitchell County, live two immigrants to the Southern Appalachians who have looked to the past for a way to enrich their present lives. Don Vermilyea and Pat Tompkins have reclaimed from the woods a hundred-year-old farmstead and have begun a pattern of life that will lead to old-time self-sufficiency.

One aspect of this life that recalls times gone by is their annual harvest of maple syrup. Scattered throughout the woods surrounding their clearing are sap buckets hanging from spiles inserted in the maple trees. The tap-tap-tap of sap dripping into the buckets ticks off the time on a warm day.

"You want warm, unwindy days with the temperature around 40-50-60 degrees. At night it needs to go down to the teens or twenties, the low temperatures bring the sap

*Don checks the maple sap buckets.*

*Don shows Dylan, Mitchell, and Blanche how sap runs into the bucket.*

back down into the roots," says Don, as he weaves his way through his trees, checking on his buckets.

He has spent many years performing the same late winter rituals. Different states with different environments have taught him the ways of the sugar maple. The trees and their ways vary from place to place.

"I've sugared in Wisconsin, Vermont, Kentucky, and New York. I've sugared every place I've ever lived, but this is far

the worst," he says, gesturing to the tall, thin, grey trees that stretch their trunks to the sky.

"The maples are great, but the problem is that the trees here are basically lumber trees. Sugar trees need lots of branches with lots of leaves to make lots of sap to go down in the roots in the fall to rise in the spring.

"Here the trees are competing to get to the sun—no lower branches, not much sugar in the summer to go back to the roots to come back as sugar next spring. Also, this is the cloudiest place I've ever lived," says Don, referring to the crown of clouds that Roan Mountain wears throughout much of the year.

The season is at its end now. Only a few of the trees yield the sap that makes good syrup. It will soon be time to remove the buckets and spiles.

"The sugar maple sap season runs from late January to late February or early March around here. This year the season was 29 days. The sap season in Northern Vermont is generally mid-March to mid-April," he says, straddling a tree to remove a bucket and check the drip from the spile.

This day is another cloudy one, but a warm breeze chases winter from the stripped woods. Don points out a series of tiny holes running around a trunk. It's the work of sapsuckers who also like the sweet juice of the sugar maples.

He shows how the birds have followed a vein rising from the root of the tree. It is a technique that he uses himself. Instead of a sharp beak, he uses a 7/16 bit.

*Don opens a syrup jar.*

"When you drill a tree, it immediately knows it has an injury. It's doing everything it can to heal itself. When the sap comes out it's as clear as water, but immediately bacteria is working on it and wants to turn it yellow," Don says as he shows his visitors the rising vein with the spile and bucket.

This year, Don collected 251 gallons of sap and from that made 15 quarts of syrup, a ratio of 66 to one. He boiled the sap down on an old wood stove that sits on the porch of the hundred-year-old log cabin that served as their home for the first year of their life on Fork Mountain.

He had a special boiling pan made in Spruce Pine, and burned more wood than he cares to remember to work the sap down to the sweet-tasting syrup. The early sap yielded an almost clear liquid, but the later sap gave a hue that looks as dark as molasses.

Inside the new house he and Pat built, he places three jars on the table. There is no electricity up here in the hollow, so the beams of sun coming in the large windows illuminate the mason jars. The first contains the early syrup.

"This is the fancy grade A, and these are B and C," he says as he points to the progressively darker syrups.

The 100 percent maple syrup tastes good enough to justify all the time and work that goes into its production. There is no comparison between it and the syrups bought off the shelves of supermarkets. In fact, it's too valuable for Don to even consider selling it.

His cash crops are the blueberries, raspberries, and grapes that flourish on the land he has cleared. The maple syrup is for home consumption, a link to the past that is an important part of their present life.

"We do this because this is what we want to do. We are trying to do a living. We talk to the old-timers around here, and they remember the ways that were and get teary-eyed. We're trying to live a life most of them have left," he says.

## PUSSY WILLOW

Everyone gets spring fever. Winter's icy onslaught after the New Year satisfied our desire for ice and snow, and now we want blue birds, butterflies, and burgeoning vegetation to move onto center stage.

One of the early signs of spring that help to sustain the promise of the season is the pussy willow, a fairly nondescript plant most of the year but a true standout now. While there are over a hundred different members of the willow family in North America, the pussy willow is one of the most recognizable because of the fuzzy gray buds that emerge from its thin branches.

Growing near the edges of creeks or in seeps from mountain springs, this member of the willow family has a bushy shape, although it can grow to the size of a small tree. In the dead of winter, it looks like any deciduous bush with naked branches. The first signs of its emergence from its winter sleep are the light pussy-like buds swelling along the flexible twigs.

*Folklore says an evil wizard cursed the tree to become low and twisted.*

*Pussy willow bud breaks into yellow blossoms.*

The soft, furry buds that give the pussy willow its name have been plumping gradually for about a month now, and with the early March warm temperatures and alternating sunshine and rainfall, they have begun to burst into bright bloom.

In addition to showing that the tide has turned, a pussy willow shining with its halo of buds is beautiful in itself, and a vase of the branches brings the hope of spring into the house.

Beauty is not the pussy willow's only attraction. Deer and rabbits find its swelling buds and tender branches delicious, since it is one of the first plants to respond to the changing season. The hungry herbivores also strip off the bark from the lower trunk to satisfy their hunger for fresh vegetation.

Winter-starved birds also find tasty munchies on the limbs. Ruffed grouse eat the tender buds eagerly.

Pussy willow is a wild edible for humans, too. The inner bark is the most palatable part of the plant. It can be scraped off to be eaten raw or cooked and is an excellent source of vitamin C. The catkins are reputedly an aphrodisiac.

The most important role the willow has played for man is as the natural origin of modern aspirin, reliever of aches, pains, and fever. In the Southern Appalachians, the leaves and bark of the tree have been made into a tea to relieve pain and to reduce fever. And according to the U.S.D.A.'s *A Guide to the Medicinal Plants of Appalachia*, "The bark is reportedly an expectorant, hemostatic, astringent, and tonic."

Native Americans used the willow to treat many ills, in addition to relieving aches and lowering fevers. They created preparations to treat a variety of venereal diseases, and the dried and powdered bark was placed on the navels of new-

borns to stop bleeding and prevent infection. Similarly, they applied it to wounds for the same purpose and stuffed it up bleeding noses.

Cures for toothache, dandruff, general lack of vigor, and asthma also came from this plant. For promoting general health after the rigors of winter, both Native Americans and Appalachian settlers brewed a spring tonic from the bitter willow roots.

In folklore, pussy willows are recommended as dowsing rods, probably because of their natural affinity for water. In North Carolina, legend explains that the low, twisted pussy willow was cursed by an evil wizard to assume that shape.

According to Mary Hicks Hamilton, who wrote a folklore column for the *Raleigh News & Observer* during the middle years of the past century, the wizard tried to seduce a beautiful young girl who angrily spurned his unwelcome advances. To punish her and to change her into a form he could control, he turned her into a light gray kitten. The kitten then climbed into a willow tree to escape from her antagonist.

She hid, trembling in the tree as her pursuer climbed the branches. A good spirit took pity on her and changed her into the pussy willow.

In Russia, the pussy willow is especially esteemed as Easter approaches. Instead of adorning their churches with palms for Palm Sunday, the Russians decorate with the long branches with furry gray buds and hand out pussy willow sprays instead of palms. Mary White, a professor at Lees-McRae College, remembers that in her native New York City, the florists stock pussy willow to provide for the many Russian Orthodox Church members as the season approaches.

Whether for religious celebration or simple appreciation of its unique beauty, we welcome the pussy willow now. Soon the plump gray buds, some of which are already showing bright yellow flowers, will become the colorful catkins drooping from the branches. Spring will be here.

The following books by Michael Joslin
are available in your local bookstore or
from The Overmountain Press

The Overmountain Press
P.O. Box 1261
Johnson City, TN  37605

800-992-2691 phone
423-232-1252 fax

# Our Living Heritage

## Michael Joslin

*Our Living Heritage* presents an inside look at the vitality of the Southern Appalachian culture that has persisted throughout the turbulent Twentieth Century. Caricature for decades by the mass culture as Snuffy Smiths and Li'l Abners and Beverly Hillbillies, the people of the mountain coves and ridges have maintained a family oriented, self-sufficient lifestyle coveted by many today.

The many narratives piece together to form an heirloom quilt of mountain life. Personal stories, historical sketches, descriptive pieces, articles on mountain lore and crafts, and even an authentic ghost story provide variety in a coherent whole. Complementing the text are Michael Joslin's color and black-and-white photographs that capture the vitality that word often miss.

Whether read from cover to cover or dipped into like a cool mountain spring, Our Living Heritage will refresh and invigorate you, and give you hope for the future. These are not stories and pictures of the past, but tales and photographs that show how hard work and faith in well-worn ways have preserved a worthy, rewarding way of life.

Published 1998
199 pages with 16 color photo insert
6" x 9"
ISBN: 1-57072-079-7
Trade Paper
$19.95

# Mountain People, Places and Ways
## A Southern Appalachian Sampler

Michael Joslin and Ruth Joslin

These stories were written and the photographs taken between the summer of 1985 and the fall of 1991 for the Johnson City Press, a daily newspaper in Johnson City, Tennessee. As the title suggests, this is a sampler, a celebration of mountain life. The authors have brought together a wide variety of articles and photographs to fascinate anyone with an interest in the Southern Appalachians. If you are interested in history, ecology, people, customs, arts and crafts, or wildlife, you will be delighted to discover it all here. There are even recipes for those who want practical knowledge from their reading.

Complementing the written descriptions are Michael Joslin's exceptional photographs, which depict the beauty and strength of the culture in its natural surroundings. Useful as well as enjoyable, this is a valuable volume for today and will be a cherished heirloom in years to come. Whether you read it from cover to cover or just pick it up to sample a story in a free moment, you will be richly rewarded.

Published 1991
282 pages
6" x 9"
ISBN: 0-932807-65-8
Trade Paper
$12.95

# More Mountain People, Places and Ways

## Michael Joslin and Ruth Joslin

The authors have brought together another outstanding collection of articles and photographs that capture the spirit of the Southern Appalachians. This volume draws its material from the same wealth of mountain culture as the first, with stories and photographs of the mountains of today and yesterday creating a vivid picture of a vital way of life.

Long-time mountain dwellers will find that the Joslins "ain't put nothing in and ain't taken nothing away," as one satisfied reader of the first volume explains. Familiar friends and lifelong ways of getting along in the invigorating but sometimes harsh climate will be recognized and appreciated. And more of Michael Joslin's outstanding photographs are included in this volume.

Those who love the mountains and cherish their people, places, and ways will find this book a joy to read now and one to be treasured for years to come.

Published 1992
282 pages
6" x 9"
ISBN: 0-932807-83-6
Trade Paper
$12.95